PHOTOGRAPHY SPEAKS II

From The Chrysler Museum Collection

70 PHOTOGRAPHERS ON THEIR ART

PHOTOGRAPHY SPEAKS II

From The Chrysler Museum Collection

70 PHOTOGRAPHERS ON THEIR ART

BROOKS JOHNSON

Aperture/The Chrysler Museum of Art

CONTENTS

PREFACE

This book, *Photography Speaks II,* is published as the sequel to a book published in 1989 entitled *Photography Speaks.* These books are intended to be companion volumes, providing the user with an overall survey of the history of photography. Since its publication, *Photography Speaks* has become a valuable supplemental text on the history of the medium. I compiled the first book to fill an educational void that I suspected was not being met at that time. That this need existed has been confirmed by the number of people who have purchased the book and have taken the time to tell me directly how much they have enjoyed it. *Photography Speaks* has proven its usefulness to a wide range of people — from the uninitiated to scholars, from writers to teachers and students. It has been extremely gratifying to learn that it is being used in classrooms around the country. Thus, *Photography Speaks* has done exactly what it was supposed to do: provide a readable and enjoyable, yet meaningful, introduction to the history of photography.

In the hope of repeating and enhancing that contribution, I have compiled *Photography Speaks II* using the framework of the earlier book. This new book follows the same photograph–statement–biography format established in the first book. An image is reproduced on the page opposite a statement by the photographer. This statement is accompanied by a brief biographical text, placing that artist within an historical context. The living artists were asked to submit statements, while texts by the deceased artists were taken from original correspondence, previously published texts, or interviews. Some of the texts deal with the specific image that has been reproduced, while others take a broader approach, commenting on the art of photography in general. A few texts are technically oriented, and some consider the facets of art creation. Overall, these statements provide a good overview of a wide range of thoughts on photography.

The first *Photography Speaks* featured sixty-six photographers who were chosen to represent a history of the medium. Naturally, many photographers had to be left out of such a limited selection. The same is true of this book in which seventy artists are featured. But, by using the two books together, a more thorough representation of the history of photography is achieved. For example, the first

book included no artists working with the first photographic invention — the daguerreotype. *Photography Speaks II* features three artists who worked with this medium. In the first book, less than a dozen nineteenth-century photographers were included; this book expands that number to twenty-three. The most recent image in *Photography Speaks* was dated 1983, while *Photography Speaks II* updates the chronology to 1990. Additionally, recognizing the impact of emerging digital technologies, this new book includes the work of two artists who use computers to create their art.

The photographs in the original *Photography Speaks* were chosen from a private collection. All of the photographs in this book come from the collection of The Chrysler Museum of Art. However, this book should not be considered a handbook of the Museum's photography collection since *Photography Speaks II* is not all-inclusive. The photographs in *Photography Speaks II* were chosen from the collection to complement the first *Photography Speaks*.

The publication of *Photography Speaks II* coincides with an exhibition of the same title on view November 12, 1995 through March 31, 1996 in the Alice and Sol B. Frank Photography Gallery at The Chrysler Museum of Art. It is expected that the book will have a far longer life and reach a much larger number of people than the exhibition alone.

Finally, I hope that *Photography Speaks II* will be an informative and enjoyable addition to literature, guiding viewers to a better understanding of the wondrous medium of photography.

ACKNOWLEDGMENTS

This book has been a great pleasure to assemble. There have been many people who have assisted at every step, to each of them goes my sincere thanks. Naturally, thanks must begin with the photographers who created the images and kindly agreed to allow them to be reproduced. All of the objects in this book are drawn from The Chrysler Museum of Art's collection. My thanks to the individual donors and members of the Photography Alliance of The Chrysler Museum who, through gifts of objects and funds, have helped to create this collection. Additionally, my deepest thanks to The Horace W. Goldsmith Foundation for its support in building the Museum's collection, and for their grant to help fund publication of this book.

Many people at various museums, collections, and libraries have assisted with many different requests. They include Pierre Apraxine, Gilman Paper Company Collection; Melinda Barlow and Mary DelMonico, Whitney Museum of American Art; Tom Beck, Kuhn Library, University of Maryland; Peter Bunnell, Princeton Art Museum; Kathleen A. Erwin, the Warren and Margot Coville Photographic Collection; Paula Richardson Fleming, National Anthropological Archives, Smithsonian Institution; Violet Hamilton, Michael Wilson Collection; Mark Haworth-Booth, Victoria and Albert Museum; Mary Panzer, National Portrait Gallery, Smithsonian Institution; Ann N. Paterra, Harry Ransom Humanities Research Center; Lori Pauli, National Gallery of Canada; Pam Roberts and Gill Thompson, The Royal Photographic Society; John B. Rohrbach, Amon Carter Museum; Maia-Mari Sutnik, Art Gallery of Ontario; Barbara Tannenbaum, Akron Art Museum; Georges Vercheval, Musée de la Photographie, Belgium, and Karyl Winn, University of Washington Libraries.

Thanks to the artists' estates, assistants, dealers, and galleries: Jane Halsman Bello; Kristin Boline; Russell Burrows; Anne Kennedy, Mimi Brown, Art + Commerce Anthology; Evelyne Z. Daitz, Witkin Gallery; Catherine Edelman; Jeffrey Fraenkel; Howard Greenberg and Sarah Morthland; Mame Kennedy and Edward Maxey, Robert Mapplethorpe Foundation; Charles Isaacs; Hans Kraus and Geralyn Flood; Peter MacGill and Margaret Kelly; Christopher Meatyard; Laurence Miller

and Vicki Harris; Lloyd and Doug Morgan; Steven Porter; Jill Quasha; Ingrid Raab; Jonathan White, and Linda Wolcott-Moore.

Additional thanks to other individuals who have lent their time and expertise to the project. These include William Clift, Janet Dewan, Anne Horton, Carol Nigro, and Naomi Rosenblum. Thanks also to Michelle Lamunière and Ronald Crusan for their assistance in writing the photographers' biographies. It should also be noted that the staff at Aperture has been helpful and enthusiastic since this book was first proposed, especially Michael Sand and Michael Hoffman.

Many members of The Chrysler Museum of Art staff have been helpful in preparing this book. Special thanks to the Museum Library staff for their diligence in securing many inter-library loan requests, including Rena Hudgins, Susan Midland, and Julia Burgess. Thanks to Georgia Lasko for tasks too numerous to list here; to Lolita Liwag-Sutcliffe for editorial assistance and copy editing; and to Scott Wolff for making the reproduction photographs. Thanks also to all of the other Museum staff who assisted in various capacities, including Robert H. Frankel, Catherine Jordan, Irene Roughton, Willis Potter, Susan Christian, Richard Hovorka, Carol Cody, Lisa Wideman, and Adeyemi Oyeilumi.

My heartfelt thanks to Robert B. and Joyce F. Menschel for their continued friendship and support. Finally, warmest thanks to Alice R. Frank for making possible the photography program at The Chrysler Museum of Art and, in turn, this book.

INTRODUCTION

As photographers, we turn our attention to the familiarities of which we are a part. So turning, we in our work can speak more than of our subject—we can speak with them; we can more than speak about our subjects—we can speak for them. They, given tongue, will be able to speak with and for us. And in this language will be proposed to the lens that with which, in the end, photography must be concerned—time, and place, and the works of man.

Dorothea Lange

Photography has often been called an international language. Unlike verbal language in which a sound represents a specific meaning, a photograph—because of its pictorial quality—communicates a concept visually. In her quote, Lange suggests that a subject speaks through the photographer and that the photographer speaks through the photograph. Thus, this symbiotic relationship results in a collaboration between photographer and subject. Although some do not, many photographs do speak of time and place. Regardless of the message communicated by the photograph, those that are timeless continue to sustain our interest as viewers.

The immediate and realistic nature of photography does something that no other medium can do: record and present an accurate impresssion of what was before the lens. Of course, it is a subjective truth, depending upon what the photographer included or excluded from the picture frame. There are some who would go so far as to argue that the photograph can never be truthful because it is made by a person with a specific viewpoint, and the image can be manipulated to support that individual's prejudices. However, the integrity of a photograph can still be compromised by the words that are placed with the image. Thus, the entity that determines the circumstances of how a photograph is presented controls the power of the image. To help illustrate this concept, consider two prime examples of manipulation and control: one by nineteenth-century photographer Alexander Gardner and a more recent example by the United States Government.

In 1866, Alexander Gardner published *Gardner's Photographic Sketch Book of the War.* This two-volume book contained 100 albumen prints documenting Civil War battle sites. An ardent supporter of the Union, Gardner used the publication of the *Sketch Book* to send a moralizing message about the war. In the introduction he wrote:

> In presenting the *Photographic Sketch Book of the War* to the attention of the public, it is designed that it shall speak for itself....Verbal representations of such places, or scenes, may or may not have the merit of accuracy; but photographic presentments of them will be accepted by posterity with an undoubting faith.

Clearly, Gardner expected the viewer to accept the believability of his *Sketch Book* by relying on the photographs to reveal the truth. However, what viewers at the time did not know or understand was that Gardner had manipulated the creation of the photographs and had written the accompanying text with a bias toward the Union. A paramount example can be found in *Home of a Rebel Sharpshooter* (p. 31). To make this photograph Gardner dragged the dead soldier into position, propped up his head and added the rifle for effect. His uniform reveals that he was not a sharpshooter, nor was the rifle of the type used by sharpshooters. Gardner then fabricated the accompanying text to create a more dramatic and poignant story. With this image, and the *Sketch Book* as a whole, Gardner created one of the earliest examples of photographic and textual manipulation for the consumption of an unwitting public.

The quintessential example of photography employed for the purposes of propaganda was conducted by the United States Government between 1935 and 1943. Although it operated under several names, what has become generally known as the Farm Security Administration (FSA) orchestrated an extensive photographic documentation of the living conditions of people in the rural areas of the country. The intent was to show how bad conditions were during the Great Depression and then to show how the government's New Deal programs were helping people. The photographic division of the FSA was conceived purely as a politically-motivated activity to win public support for the government's new social programs. During its lifetime, roughly a quarter of a million negatives were made in the service of this project. Yet, within these images there are some that endure and rise above the mundane. Among them is Dorothea Lange's photograph *Men Cradling Wheat* (p. 89). This archetypal image conjures similar savory

sensations that can be associated with the harvest in all cultures. It is a universal image in which the agrarian activity depicted is necessary to the basic functioning of the human body, and thus, the flourishing of any civilization. While this image depicts an earthy process, it is Lange's graceful and poetic interpretation of the scene that makes it memorable and timeless. This photograph is reminiscent of the humble genre scenes of the French Barbizon painters who frequently depicted the virtue of work and a simple lifestyle. Yet, the meaning of this photograph could change depending upon its context and the words placed with the image. The image could be used as an advertisement for breakfast cereal or as a political statement representing the power and unanimity of the proletariat in the communist system.

Both of these examples—Gardner, and more recently Lange, under the auspices of the FSA—show how the photograph was expected to speak to the masses, to be accepted as fact. Yet despite the ulterior motives, some images emerge as icons with a life far beyond their original intent. It is these images that capture our interest and are considered within the larger study of the history of photography.

Most of the images in this book are here because the original artistic intent of the creator was successful. Others are here because they possess merit and a longevity beyond their original purpose. Although some of the images were made for utilitarian purposes, they were nonetheless created using the best artistic inclinations of the maker. These images range from the daguerreotype to the digital. Since its birth, photography has been used for multiple purposes. Although William Henry Fox Talbot was quick to point out the many uses for which his new invention could be used, it was Henry Peach Robinson, in 1896, who worried that perhaps photography was becoming too useful for "everybody's business except its own." Robinson believed in photography as a medium for the creation of pure artistic work. Yet, what he failed to understand or accept was that photography was much too versatile to be relegated to a single role. As a tool, its multiplicity of functions ranges from simple recording to scientific documentation to business enterprise, and of course, to the conscious attempt to create a work of art. This is not to say that photographs made for other more specific purposes are not, or cannot become works of art.

Almost immediately after its invention, people began using photography for a variety of purposes. In 1851, Félix Teynard photographed the exotic monuments of Egypt as "souvenirs" of his trip along the Nile. In 1852, Dr. Guillaume-Benjamin

Duchenne became convinced of the need to use photography to document his experiments with electrical currents to make "the facial muscles contract to speak the language of the emotions and the sentiment." As early as 1842, the Langenheim brothers were engaged in the business of portraiture, but for them, portraiture was a transaction offering "the feelings of our hearts" created by the *"Pencil of Nature."*

Although photography was used for utilitarian purposes, there was always an overarching concern with the creation of art. Even Duchenne, whose portraits were ostensibly documents of a scientific process, was compelled to write that "in photography, as in painting or sculpture, you can only transmit well what you perceive well. Art does not rely only on technical skills." During his day, Duchenne's photographic work would not have been considered to be within the arena of art, yet, the artistic quality of photography was a concern to him. Audiences today might find Duchenne's repeated portrait images surprisingly modern in their handling and presentation.

As the end of the millennium approaches, artists are increasingly using photography for innumerable purposes. With the advent of the digital age, photographers can now create fantastic landscapes of scenes that have never existed and portraits of people who have never lived. As we enter this new age, the future of photography seems limitless, much as it must have seemed upon its invention 150 years ago. Throughout its history, photography has spoken and will continue to speak to us in a myriad of ways. While the photograph can and does speak, it is the ventriloquist who presents the image that ultimately controls the message. The photographs in this book are presented here with text by the photographers who made them. Indeed, it seems most fitting that they, the creators, should have the final word.

PHOTOGRAPHY SPEAKS

William Langenheim
American (b. Germany), 1807–1874

Frederick Langenheim
American (b. Germany), 1812–1879

The Langenheim brothers immigrated to America in the 1830s, and by the early 1840s were operating a successful daguerreotype studio in Philadelphia; some of their more illustrious clients included Henry Clay, Andrew Jackson, and Martin Van Buren. A contract to procure exclusive U. S. rights to William Fox Talbot's calotype invention — the first negative/positive process — led to near financial disaster in 1849. However, the Langenheims quickly recovered with their introduction of glass transparencies (lantern slides), stereoscopic paper prints and slides. The following two advertisements from Philadelphia newspapers illustrate their sales strategies:

NOTHING can be more affecting and exciting to the feelings of our hearts than to take to hand an excellent Daguerreotype portrait of a parent, a brother or sister, a child, a friend or anyone else we love, after they are "far away" or dead. No limner's brush, no engraver's steel, no lithographer's ink is able to produce a likeness so striking-pleasing and lifelike as the Daguerreotype, which is not done by the hand of an artist, but by the *Pencil of Nature*. Everyone knows that in this process the artist has merely to follow Nature's unchangeable laws in preparing the plates, and that Light, the first created Element, draws the picture. It is true, that not every operator knows how to apply these laws, and in consequence not every picture is what it ought to be; but if you want to procure one good in every respect go to the old reliable establishment of LANGENHEIM DAGUERREOTYPE EXCHANGE.

IF YOU WANT A REALLY GOOD PICTURE of yourself, your relations or friends — if you want a family group well arranged — if you want the picture of small children taken in the quickest possible time — if you want a portrait set in a breastpin, bracelet, locket or finger ring — if you want a copy of a Daguerreotype, painting, engraving, or other artistical production — if you want a portrait of a deceased or sick person taken at home — in short, if you want anything superior in the Daguerreotype line, go to the old and far-famed establishment of W. & F. LANGENHEIM.

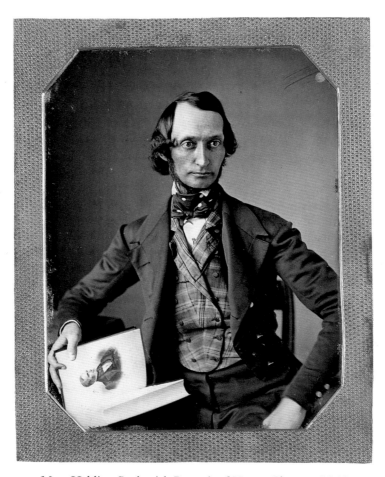

Man Holding Book with Portrait of Henry Clay, ca. 1848
Daguerreotype
4¾ x 3½ inches
Horace W. Goldsmith Fund, 89.77

Mathew Brady
American, 1823–1896

One of the most well-known photographic entrepreneurs of the nineteenth century, Brady became famous for his portraits of politicians and celebrities. He owned galleries in New York and Washington in which he employed accomplished operators who maintained a high level of quality. Brady personally took few, if any, of the photographs that bear his studio name. However, he achieved much notoriety for financing the first comprehensive photographic documentation of the Civil War. In the following passage taken from an 1891 interview with George Townsend, Brady reminisces about his days of glory and how he managed to photograph the "Swedish Songbird," Jenny Lind:

How old are you, Mr. Brady?" Never ask that of a lady or a photographer; they are sensitive. I will tell you, for fear you might find it out, that I go back to near 1823–24; that my birthplace was Warren County, N.Y., in the woods about Lake George, and that my father was an Irishman….

I entered at last into business, say about 1842–43. My studio was at the corner of Broadway and Fulton streets, where I remained fifteen years, or till the verge of the Civil War. I then moved up Broadway to between White and Franklin, and latterly to Tenth street, maintaining also a gallery in Washington City. From the first I regarded myself as under obligation to my country to preserve the faces of its historic men and mothers. Better for me, perhaps, if I had left out the ornamental and been an ideal craftsman!

"What was the price of daguerreotypes forty-five years ago?"

Three to five dollars apiece. Improvements not very material were made from time to time, such as the Talbotype and the ambrotype. I think it was not till 1855 that the treatment of glass with collodion brought the photograph to supersede the daguerreotype. I sent to the Hermitage and had Andrew Jackson taken barely in time to save his aged lineaments to posterity. At Fulton street, bearing the name of the great inventor before Morse, I took many a great man and fine lady….

"Jenny Lind?"

Yes, Mr. Barnum had her in charge and was not exact with me about having her sit. I found, however, an old schoolmate of hers in Sweden who lived in Chicago, and he got me the sitting. In those days a photographer ran his career upon the celebrities who came to him, and many, I might say most, of the pictures I see floating about this country are from my ill-protected portraits. My gallery has been the magazine to illustrate all the publications in the land. The illustrated papers got nearly all their portraits and war scenes from my camera….

My wife and my most conservative friends had looked unfavorably upon the departure from commercial business to pictorial war correspondence, and I can only describe the destiny that overruled me by saying that, Like Euphorion, I felt that I had to go. A spirit in my feet said, "Go," and I went. After that I had men in all parts of the army, like a rich newspaper. They are nearly all dead, I think. One only lives in Connecticut. I spent over $100,000 in my war enterprises. In 1873 my New York property was forced from me by the panic of that year. The Government later bought my plates and the first fruits of my labors, but the relief was not sufficient and I have had to return to business.

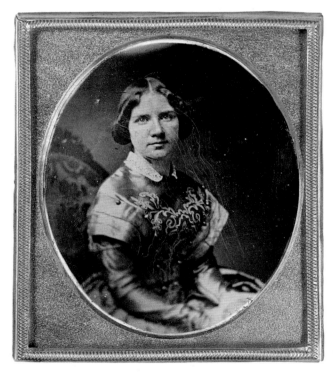

Jenny Lind, 1852
Daguerreotype
3¼ x 2¾ inches
Purchase, partial gift of Kathryn K. Porter, and Charles and Judy Hudson, 89.75

Antoine François Claudet
French (worked in England), 1797–1867

An innovator and champion of photography as an art form, Claudet learned the daguerreotype process from its inventor Louis J. M. Daguerre. Claudet opened London's second daguerreotype studio and in 1853, became the official photographer to Queen Victoria. Credited as the inventor of the daguerreotype stereograph, Claudet is recognized for his exquisite hand-colored portraits. Claudet was a prolific writer on the technical problems and artistic attributes of photography. In the following text from the American publication *Humphrey's Journal of Photography,* Claudet expounds on photography as art:

When the present state of photography was considered, and the vast strides it had made during the last four years, it would seem that a more perfect process could scarcely be wished. The highly sensitive plates on which even such subjects as the waves of the sea could be fixed, were results which only a few years ago would appear difficult to have attained; and supposing photography to make no further progress, it was in its present state a most valuable auxiliary to the artist, as an agent in the hands of whom its application required taste and discrimination.

In taking a picture the first care was to select a fine subject, and that attained, the next point was the selection of a proper point of view from which to take it, and, lastly, the hour of the day at which the lights and shades would be most effectively rendered; for, by taking the same view under different conditions of light, very important changes were apparent. All these points having been attended to, the photographer should then never leave the place until he had obtained as perfect a picture as possible. He must seize his subject at precisely the right moment, otherwise, although he might obtain a perfect photograph, it would not be an artistic picture.

Photography was an art in which only genius and talent could rise to a high position. In the immense number of photographs exhibited during the past five years, how small was the number meriting the designation of really fine photographic pictures! There was neither pleasure nor merit in doing that which did not cost trouble or talent.

Photography would increase the taste for the productions of art; and, reciprocally, art would increase a taste for photography. Photography was the imitator of nature — the drawing was perfect, and the perspective correct. It was the image of the objects depicted in the retina which, if transitory, still was susceptible of leaving on gifted minds an impression capable of being continually recalled by the powers of memory. Photography was to the fine arts what logarithms were to mathematics; by its means work was more easy and was more rapidly accomplished. It was to the artist a vocabulary which guides him as the handbook of nature.

Since photography had been invented because fine art was in want of it, was it not ridiculous to suppose that art could be injured by it? In miniature painting it had been of the most signal advantage, as it very materially shortened the sittings. A photographer of taste, feeling, and judgment, although not a painter, might yet know how to place a model so as to give the greatest possible grace to a picture, and a painter could not fail to find among the productions of such many excellent models for study, as photographers arrange and pose many subjects daily, while the painter only arranges what he can paint.

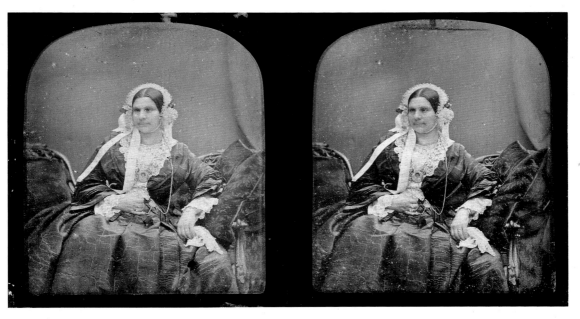

Portrait of a Woman, ca. 1855
Hand-colored daguerreotype stereograph
3¼ x 7 inches overall
Gift of Robert W. Lisle, 91.101

Thomas Rodger
British, 1833–1883

Rodger learned the mechanics of photography from his medical professor Dr. John Adamson, in Glasgow, Scotland. Dr. Adamson was also responsible for instructing his brother Robert Adamson, who entered into a famed photographic collaboration with the painter David O. Hill. Rodger operated his own photographic studio in St. Andrews, Scotland, and according to his obituary published in *The British Journal of Photography,* he was, "a born artist, and...gained for himself a name and fame which became known throughout every region of the globe." The obit also notes that "with children he was particularly successful." In this text, Rodger discusses his techniques, especially his use of various formulas to achieve different results according to the subject:

I can say little about the time the plate must be exposed in the camera, further than that, with my lenses, which are by Ross and Lerebours, and have moderate diaphragms, and with the chemicals prepared according to the formula given, my usual time of exposure (in shade) for negatives is in summer from five to thirty seconds, according to the hour of the day; and that at the present season, in the early part of a good day, it is about the same.

The quarter from which I have almost always managed to receive my light is the north-east. The steady character of light coming from this direction renders it a matter of consequence, in taking a portrait especially. To develop the image, I have long employed two different solutions; using either according to the character of the object, and the quality of the light. I shall first give the formula, and then make a remark or two regarding their application.... For a landscape No. 1 is excellent, bringing up, as it does, the parts in deep shadow, which would with many other developers be utterly lost. In portraits of gentlemen, No. 1 is also specially applicable and I always prefer it for such, as without approaching to

hardness, I obtain by it a very pleasing decisiveness of light and shadow. But, for ladies, I think too much care cannot be taken to avoid a rapid passage from lights to shadows in photographs. Therefore, to obtain that delicate and softened effect so suitable and necessary to the subject, I certainly prefer the latter solution. Very often, however, in fine light and warm weather, I as readily make use of No. 1.

The spirit is employed merely to ensure a ready mixture between the bath on the plate and the developer.

When I develop a picture, I pour on the developer and give the plate a little motion, so as to mix whatever nitrate of silver is on the surface with the developing solution, to secure uniform action; and, after the image seems pretty decided and intense, I raise the plate and examine for an instant by transmitted light. If there should happen to be a thinness or want of intensity in the deposit, I mix half a dram of a weak solution of nitrate silver with what was poured off, and pour it off and on the plate several times, or until I obtain the opacity which I desire; after which I immediately wash in the ordinary way before fixing.

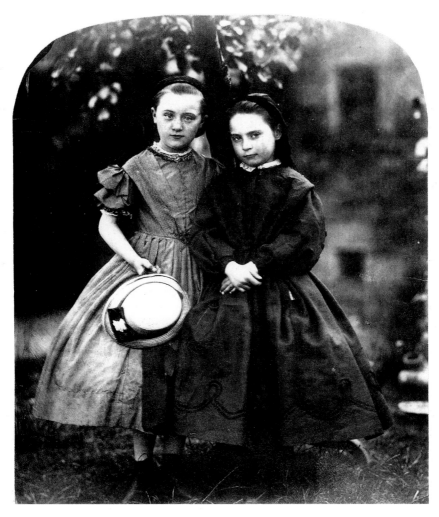

Cousins, ca. 1855
Albumen print
7½ x 6⅛ inches
Horace W. Goldsmith and Art Purchase Funds, 91.29

Félix Teynard
French, 1817–1892

In 1851 and 1852 Teynard, a civil engineer, traveled throughout Egypt recording the country's landscape and architectural monuments. Teynard was interested in capturing the patterns created by the contrasts of light and shadow, and his photographs display a unique balance of information and design. Originally issued beginning in 1853 Teynard's salted paper prints were published in two volumes under the title *Égypte et Nubie: Sites et monuments* (1858), a travel album considered to be one of the masterpieces of nineteenth-century photography. Teynard's description of the voyage, excerpted from *Égypte et Nubie*, follows:

The plates included in this work were photographed as souvenirs during a voyage that we made in the years 1851 and 1852. The edifices of the different eras, the banks of the Nile, the wretched dwellings of the fellahin, were taken one after another to recall the sensations experienced during the many months that we passed, alone, among the inhabitants of Egypt and Nubia. The monuments of ancient Egypt deserved the larger share of the photographs, since, from the historical and architectural points of view, they represent an account of the most ancient civilization that has come down to us. It is regrettable that the complete gloom that reigns inside the tombs and temples cut into the flanks of the cliffs does not permit the photographing of the exceedingly harmonious and remarkable paintings that decorate their walls. The absence of windows in Egyptian buildings also prevents the possibility of obtaining interior views unless collapsed ceilings allow the penetration of the sun's rays.

We brought back photographs of all the buildings of any importance that still stand in the Nile valley. When the monuments were numerous, and when the distribution of locations permitted, we took an overall view, detail views, and examples of the sculpture. Many of the photographs are far from being irreproachable, but the traveler perhaps has the right to some indulgence when his meticulous work is carried out in a country like Egypt. Isolated in a region without resources, he can count on himself alone; pressed for time, the slowness of the means of transportation does not permit him to retrace his steps; as a nomad, his installation is always temporary, and the delicate preparations for photography must be done, sometimes with the lurching of a sail boat, sometimes beneath a tent set up in the middle of the desert.

These statues…represent [Amenophis III]…. They are 18 meters apart and face the southeast. Their height is approximately 16 meters from the tops of the partially buried bases which are 4 meters high. The left colossus is a monolith of very hard crystalline sandstone, brought from the southern Thebaïd. The one on the right, given the name Memnon by the Greeks, was also a monolith, but…it was broken across the center during an earthquake. When it was hit by the rays of the rising sun, the part that remained in place gave off sounds which Pausanias compared to those produced by a lyre string when it breaks. A large number of travelers, among them the Emperor Hadrian, witnessed this phenomenon. These sounds came from the disintegration of the stone caused by the heat of the sun vaporizing the humidity absorbed during the night. These conditions were changed by Septimius Severus, who had the colossus repaired. Since that time, its melodious voice has ceased.

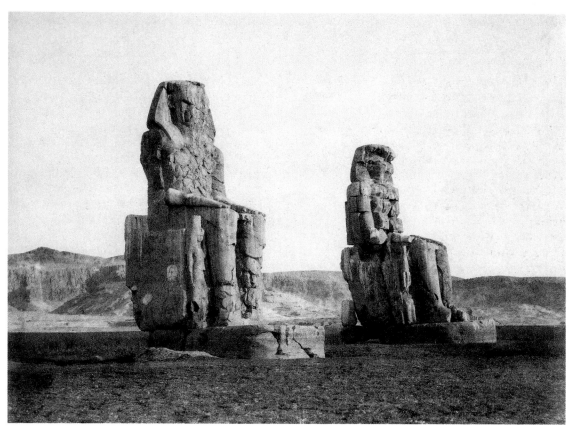

Colossi (The one on the right called the Colossus of Memnon), Qurna (Thebes), 1851–1852
Salted paper print from a waxed paper negative
9¼ x 12 inches
Purchase, partial gift of Alice Frank, 93.47

Gustave Le Gray
French, 1820–1882

Trained as a painter, Le Gray was among the earliest to perceive the artistic potential of the new medium of photography. He is recognized as one of the pioneers of photography as art. His seascapes of the 1850s illustrated how light — at its most brilliant moment — could define a scene and that this depiction of light could be the focal point for a work of art. This concept was later realized in color by the Impressionist painters. Constantly striving to improve the technical shortcomings of the medium, this 1850 English translation of *Le Gray's Practical Treatise on Photography* offers some advice:

The extensive application that I have been enabled to make for several years of the art of Photography, as a means of obtaining an exact re-production of nature in all its aspects, Landscapes, Monuments, Pictures, & c., has opened to view its immense importance, and urges the necessity of a sure method, without restriction, which will facilitate its employment by the Artist and Amateur.

I wish to be useful, both to one and the other, in the publication of this process, which my research and experience has made known to me as the most certain and practicable.

The future and extensive application of this art will, doubtless, be confined to the paper process, and I cannot too much engage the amateur to direct his attention and study to it.

The negative proof upon glass, it is true, is finer, but I think it is a false road, and it would be much more desirable to arrive at the same results, with the negative on paper.

Glass is very difficult to prepare, fragile, and inconvenient to travel with, and less rapidly operated upon by the light.

Thus, though its results are extremely delicate, I would strenuously urge the perfection of paper fabrication, as a means to arrive at the same delicacy of detail which is produced upon glass.

That this is possible, I am certain, from some perfect results that I have obtained.

Nevertheless, by the application of a coat of albumen on paper, we can obtain results which are equally perfect with those upon glass.

All will agree that paper is more convenient for travelling, as glass is weighty, fragile, and, if broken, may be difficult to procure in some places.

It is for this reason that I would wish Artists not to be dazzled by the beautiful results upon glass, and not to be discouraged in their pursuits upon paper. It should be, on the contrary, a subject of emulation to perfect the results upon that material.

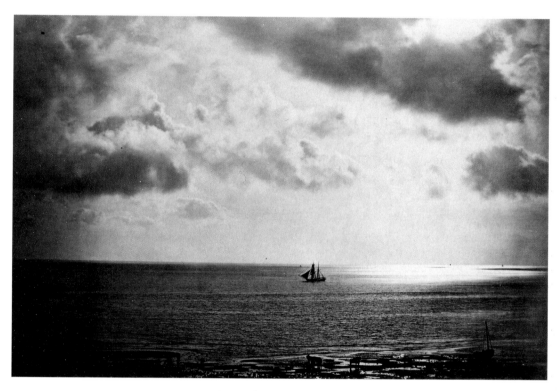

Brig on the Water, ca. 1855
Albumen print from wet collodion negative
12 x 16 inches

Purchase, partial gift of Mr. and Mrs. Calvin H. Childress, Mr. and Mrs. Chris A. Crumley, Mrs. Alice R. Frank,
Dr. and Mrs. George M. Kemp, Mr. and Mrs. Harry Lester, Mr. and Mrs. Arnold B. McKinnon, Dr. Patricia L. Raymond,
P. L. Wilds, Landmark Communications Art Trust, Art Purchase Fund, and an Anonymous Donor, 94.33

Linnaeus Tripe
British, 1822–1902

Prior to being hired to photograph antiquities by the British East India Company in 1855, Captain Tripe was photographer to the British mission at the court of Ava in Burma. For thirty-six days he battled unfavorable working conditions and weather to produce a series of Burmese views published for the Madras Photographic Society in 1857. These images, as well as a group of stereoscopic views taken in 1858, reveal Tripe's interest in picturesque representations of monuments in natural settings. The following passages, which are excerpted from letters and a brief text written by Tripe, describe the difficulties he met in completing his assignment for the Government and his resultant frustrations:

The accompanying views, taken by the undersigned when attached to the Embassy to Amerapoora in 1855, in justice to him as a photographer employed by the Government of India, should not be looked upon as a challenge to Photographic criticism; but as a series of views of subjects interesting on account of their novelty; many having been retained solely on that account when they would certainly have been otherwise discarded. As excuses, too, for these defective photographs he would wish it known, that he was working against time; and frequently with no opportunities of replacing poor proofs by better. Also that, from unfavourable weather, sickness and the circumstances unavoidably attending such a mission, his actual working time was narrowed to thirty six days....

If during the hot season at Madras those accustomed to it feel exertion in common duties irksome, what must become of his [the photographer's] energy who, instead of a well ventilated office with all appliances for banishing heat and discomfort, has a room where no air in movement is allowed because of dust, and no ventilation because of white light, the temperature higher than outside, the atmosphere a mass of chemical evaporations. This is his Workroom; what does his Work become? All the better because carried on under such difficulties? By no means. Perspiration, impatience, failure, mutually act and react on each other. If at all successful, it can only be partially so because of deteriorated chemicals....

Two causes have retarded [printing] work — sickness among my assistants from working in close rooms, during the hot weather; and rain experiments, to enable me to work during the monsoon, have also tended to retard progress.

One cause of the amount of failures [unsatisfactory prints], has been the newness of the work to those assisting me, and also the fact, that (in this country especially), the wax, used to render the negatives transparent, is melted out, by the heat of the sun, in printing and spots the first-positives so as to spoil them....

I have had no leave of any kind since December 1854, but have been closely at work for most of the interval. It is not to be supposed, that, because Photography is taken up as an amusement by so many, that when pursued zealously as a duty, that duty is slight. On the contrary, I declare seriously, that I have never had such hard work, as I have had during the last two years of my life....

There is scarcely a duty more easily perverted to private pleasure or advantage than mine has been, and I feel it almost necessary to assure His Excellency the Governor in Council that I have not done so: and further that economy both of time and materials has been my anxious care from first to last.

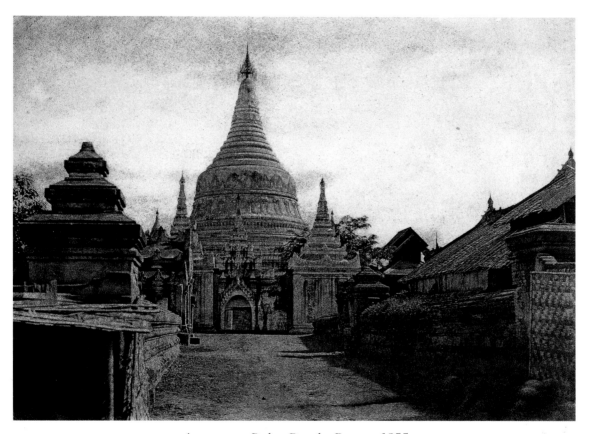

Amerapoora Bodan Pagoda, Burma, 1855
Albumen print from waxed paper negative
11 x 13¾ inches
Horace W. Goldsmith and Art Purchase Funds, 93.31.2

Francis Frith
British, 1822–1898

Frith traveled and photographed extensively in Northern Africa and the Near East in the mid-nineteenth century. His recollections of his adventures, which were intended to inform and delight the armchair traveler, were visually descriptive scenes of exotic lands. Between 1855 and 1870, he made or published over 100,000 views, many in book form. Originally published as the introduction to his 1858–1859 book *Egypt and Palestine,* the following passage clearly shows Frith's wry sense of humor:

Salaam! — Peace be with thee, oh, thou pleasant Buyer of my book!

It is my intention, should my life be spared, and should the present undertaking prove successful, to present to the public, from time to time, my impressions of foreign lands, illustrated by photographic views.

I have chosen, as a beginning of my labours, the two most interesting lands of the globe — Egypt and Palestine. Were but the character of the pen for severe truthfulness as unimpeachable as that of the camera, what graphic pictures might they together paint! But we scarcely expect from a traveller "the truth, the whole truth, and nothing but the truth."

…I hold it to be impossible, by any means; fully and truthfully to inform the mind of scenes which are wholly foreign to the eye. There is no effectual substitute for actual travel; but it is my ambition to provide for those to whom circumstances forbid that luxury faithful representations of the scenes I have witnessed, and I shall endeavour to make the simple truthfulness of the camera a guide for my pen.

Now we shall see (if my bungling does not spoil the match) what sort of chance Fact has with Fiction in the race for popularity…. A man sitting quietly at home in London or New York may write even a Book of Travel, and an artist may compose for it a series of illustrations, with every chance of success upon the most scanty materials, and with the cost and labour of travelling. It is an artist's privilege to "make a picture" of his subject; but, alas for the poor photographer! and alack for the man who will write the truth, if he can, at all hazards! — they must be dull.

A photographer only knows — he only can appreciate the difficulty of getting a view satisfactorily into the camera: foregrounds are especially perverse; distance too near or too far; the falling away of the ground; the intervention of some brick wall or other commonplace object, which an artist would simply omit; some or all of these things, (with plenty others of a similar character) are the rule, not the exception. I have often thought, when manoeuvring about for a position for my camera, of the exclamation of the great mechanist of antiquity — "Give me a fulcrum for my lever, and I will move the world." Oh what pictures we would make if we could command our points of view!

The difficulties which I had to overcome in working collodion in those hot and dry climates, were also very serious. When, at the second cataract; one thousand miles from the mouth of the Nile, with the thermometer at a hundred and ten degrees in my tent, the collodion actually boiled when poured upon the glass plate, I almost despaired of success. By degrees, however, I overcame this and other difficulties; but I suffered a good deal throughout the journey from the severe labour rendered necessary by the rapidity with which every stage of the process must be conducted in climates such as these, and from excessive perspiration, consequent upon the suffocating heat of a small tent, from which every ray of light, and consequently every breath of air, was necessarily excluded.

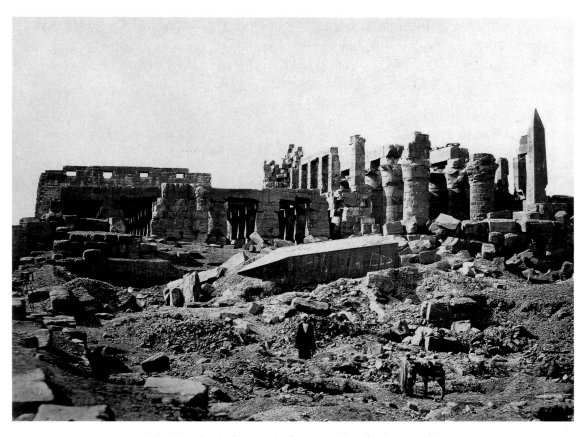

The Temple of El Karnak, from the South East, 1857
from *Egypt, Sinai, and Jerusalem,* 1858
Albumen print
15 x 19¼ inches
Horace W. Goldsmith and Art Purchase Funds, 91.94

Adolphe Braun
French, 1812–1877

Originally a textile designer, Braun began photographing flower and still life compositions in 1853. Turning to landscape imagery, he created many photographs of Alpine, Black Mountain and Vosges scenery, and supplied prints in a variety of formats, including stereoscopic and panoramic views, to subscribers throughout Europe and the United States. In the late 1860s he built a photographic printing plant that produced reproductions of artistic masterpieces. Braun refers to these reproductions as publications in the following letters to art critic and journalist Paul de St. Victor:

My establishment has a few exceptional features and I do not believe many of my colleagues have seen the need for a steam engine such as I use to operate many of the machines in my workshops.

I have always regretted the fact that the French government had never so much as condescended to acknowledge the importance or influence of our publication, in spite of the many difficulties I had to overcome in order to lower its price to make the riches of our great masters available to everyone.

M. Von Zahn, director of the Museum of Dresden has recently asked me to approach the Commission Royale for permission to photograph their Musée de la Peinture, assuring me of his unconditional support. He also advised me to emphasize to them the lack of interest of the French government in our outstanding publication. He also added that he was quite prepared to pull the most powerful levers so that we could be granted this great privilege.

As you can image I let my dignity as an Alsatian guide me in this matter and I sent in my request but chose not to allude to the French government's attitude; so I do hope you approve of my decision.

I have felt extremely gratified by this call to the public's attention, written by a man who is not only the most competent but also a master of language. This has been the greatest boost to me and no sooner are your articles published than I receive the most flattering letters from unknown correspondents.

So please accept my most sincere thanks for this latest evidence of your friendship.

You may have already seen the "Collection des Statues du Louvre." I must admit I am not entirely satisfied with it. I feel my technician has not quite captured the best angles of their faces; however, you might find some of the most famous ones quite satisfactory, considering the incoherence of the lighting as well as the numerous stains on some of the marbles....

My younger son will be in Paris for a few days and will of course call on you to pay his respects. He knows M. Ch. Blanc personally, having traveled with him to Egypt. He can pay him a professional visit and discuss with him my wish to work on some paintings. He will no doubt follow your advice on this matter.

Please accept my gift of a cask of wine from Alsace. I remember how much you had enjoyed it when you visited me in Dornach. It comes from my own vineyards and I harvest it myself. It dates from the days when the Vosges did not separate us from France.

Alpine Landscape, ca. 1860
Albumen print
7⅝ x 10¼ inches
Purchase, partial gift of Alice Frank, 93.20

Adalbert Cuvelier
French, ?–1871

Eugène Cuvelier
French, 1837–1900

Adalbert was a businessman, amateur painter, and photographer. His son Eugène was a painter and photographer. Both worked in the forest of Fontainebleau and were friendly with many of the Barbizon painters. Their photographs, which capture the beauty in nature's inherent simplicity, are quite similar and frequently indistinguishable. Although father and son used both glass plate and paper negatives, the imperfections and absorptive qualities of the paper reveal the mystical atmosphere of the forest and the smoky effects of filtered sunlight. In this excerpt, Adalbert urges his colleagues to study the artistic sensitivities of painting to become good photographers:

Many people who have never taken up either painting or drawing and know absolutely nothing about either one, imagined that the discoveries of Niepce and Daguerre would enable just about anyone who could afford a darkroom with all the Daguerreian paraphernalia, including a how to brochure, to produce wonders.

They were mistaken.

I am not saying there that one must be an expert at painting or drawing in order to become a good photographer, but what I am saying is that one must be an artist. You must have sensitivity to painting, understand its effect and composition.

Those are crucial matters if you do not want to spend your life turning out, without realizing it, a lot of ridiculous pictures, and there are too many of those out there already.

To those who wish to become decent photographers and acquire those skills, if they do not yet have them, I would say this: Get acquainted with an elite painter, someone serious, ask him for his advice and then put it to good use.

Most photographers who do only portraits might think that it is not really necessary to know how to compose a scene in order to do something so simple.

Well, those are precisely the ones I want to understand that being knowledgeable is essential, because, to me, nothing appears quite so difficult as to pose a model well and light him correctly, for the very reason that it seems so simple to do.

In the interest of photography and photographers I cannot urge amateurs enough to understand that photography is not a trade but an art and that, as a consequence, their feeling and their knowledge must be reflected in their works just as the feeling of a painter is reflected in his paintings.

In order to prove this point, one needs only to examine the work of several photographers who operate equally well and use the same techniques. Their finished products are all very different. Each one of them will have a distinctive style and it is almost as easy to recognize them as to tell a Delacroix from a Decamp or a Corot from a Troyon.

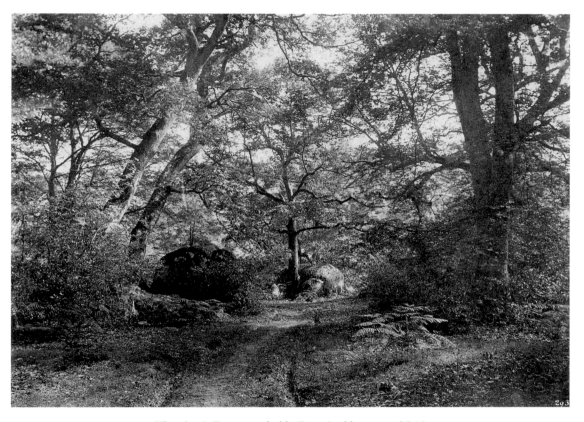

View in A Forest, probably Fontainebleau, ca. 1860
Albumen print from paper negative
9⅞ x 13⅜ inches
Horace W. Goldsmith and Art Purchase Funds, 90.328

Charles Nègre
French, 1820–1880

A respected painter, Nègre exhibited in many of the Paris salons, yet he was far more adventurous with his photography. His first well-known photographs, which were genre studies of people on the streets of Paris, were considered remarkable because of the long exposure times required in the 1850s. Because of the ordering of the space, the image *Landscape with Chapel* was considered to be quite revolutionary. Rather than a formal, straightforward presentation of the hillside, the composition has a diagonal orientation. The work could even be thought of as a precursor to the style of painting that Cézanne, working in the same area of France, was to accomplish later. The following text comes from an unpublished manuscript probably meant to serve as an introduction to Nègre's 1854 album entitled *The Midi de la France Photographed*. Commenting on the exactitude of photographs, Nègre says:

Henceforth, photography will replace that category of drawing requiring rigorous accuracy.

If art is the poetic interpretation of nature, photography is the exact translation; it is exactitude in art or the complement of art.

In giving us perspective and geometric precision, however, photography does not destroy the personal feeling of the artist: he must always know how to choose his subject; he must know how to choose the most advantageous point of view; he must choose the effect that will be most in harmony with his subject.

Photography is not a remote and barren art; it is, in fact, a rapid, sure, and uniform means of working, which is at the artist's service, and which can thus reproduce with mathematical precision the form and the effect of objects as well as that poetry which is the immediate result of all harmonious combinations.

It is not only the varied and picturesque nature of the sites, the brightness of the sun, the purity of the atmosphere that I wished to show in my photographs; in addition to the beauties with which the Creator has endowed our climes and which stem from completely physical causes, I have searched for beauty of another order which also should be of importance to us because it relates to the study of art and history. Each generation has left a visible trail of its passage across the face of the earth — such as religious monuments, public or private — and it is through the study of these monuments that, today, we may form an exact idea of the various civilizations.

Being a painter myself, I have kept painters in mind by following my personal tastes. Wherever I could dispense with architectural precision I have indulged in the picturesque; in which case I have sacrificed a few details, when necessary, in favour of an imposing effect that would give to a monument its real character and would also preserve the poetic charm that surrounded it.

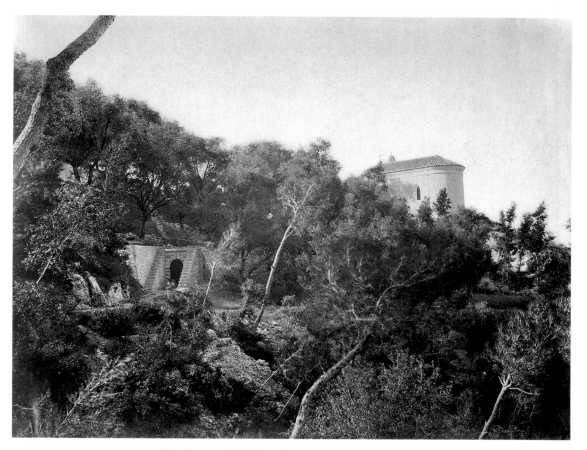

Landscape with Chapel, near Cannes, ca. 1865
Albumen-silver print
10 x 13 inches
Horace W. Goldsmith and Art Purchase Funds, 92.47

Guillaume-Benjamin Duchenne (de Boulogne)
French, 1806–1875

The founder of electrotherapy, Duchenne used photography between 1852 and 1856 to record the effects of electrical stimulation of muscles in order to determine their role in facial expression. He learned the rudiments of photography from his colleague Adrien Tournachon (also knows as Nadar Jeune; French, 1825–1903), who assisted in making some of Duchenne's physiognomic studies. In 1862, Duchenne published *Méchanisme de la Physionomie Humaine ou Analyse Électro-Physiologique de L'Expression des Passions (The Mechanism of Human Facial Expression or an Electrophysiological Analysis of the Expression of the Emotions)*, illustrated by photographs taken with Tournachon's assistance. The following statement is a translation from Duchenne's book:

Photography, as true as a mirror, can illustrate my electrophysiological experiments and help to judge the value of the deductions that I have made from them.

From 1852, convinced of the impossibility of popularizing or even publishing this research without the aid of photography, I approached some talented and artistic photographers. These first trials were not, and could not be, successful. In photography, as in painting or sculpture, you can only transmit well what you perceive well. Art does not rely only on technical skills. For my research, it was necessary to know how to put each expressive line into relief by a skillful play of light. This skill was beyond the most dexterous artist; he did not understand the physiological facts I was trying to demonstrate.

Thus I needed to initiate myself into the art of photography.

I photographed most of the 73 plates that make up the Scientific Section of this Album myself, or presided over their execution, and so that none shall doubt the facts presented here, I have made sure that not one of the photographs has been retouched.

The spirit is thus the source of expression. It activates the muscles that portray our emotions on the face with characteristic patterns. Consequently the laws that govern the expressions of the human face can be discovered by studying muscle action.

I sought the solution to this problem for many years. Using electrical currents, I have made the facial muscles contract to speak the language of the emotions and the sentiments. "Experimentation," said Bacon, "is a type of question applied to nature in order to make it speak." This careful study of isolated muscle action showed me the reason behind the lines, wrinkles, and folds of the moving face. These lines and folds are precise signs, which in their various combinations result in facial expression. Thus by proceeding from the expressive muscle to the spirit that set it in action, I have been able to study and discover the mechanism and laws of human facial expression.

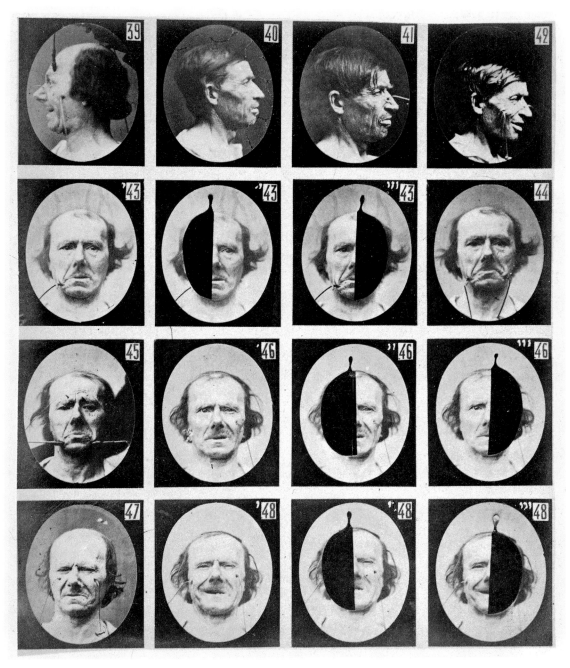

Plate 5 from *Méchanisme de la Physionomie Humaine*
ou Analyse Électro-Physiologique de L'Expression des Passions, 1862
Albumen print
5⅛ x 4¼ inches
Horace W. Goldsmith and Art Purchase Funds, 93.19.2

Alexander Gardner
American (b. Scotland), 1821–1882

A pioneering photojournalist and master of portraiture, Gardner made numerous portraits of Abraham Lincoln and other notables, including Native Americans. Gardner documented the Civil War and photographed the Westward expansion of the railroad. In 1866, he published the first photographically-illustrated book on the war, *Gardner's Photographic Sketch Book of the War.* The passage that follows is drawn from that book and comes from the introduction and commentary accompanying *Home of a Rebel Sharpshooter.* In it, Gardner presents an emotional verbal portrait as a companion to the photograph:

In presenting the *Photographic Sketch Book of the War* to the attention of the public, it is designed that it shall speak for itself. The omission, therefore, of any remarks by way of preface might well be justified; and yet, perhaps, a few introductory words may not be amiss.

As mementoes of the fearful struggle through which the country has just passed, it is confidently hoped that the following pages will possess an enduring interest. Localities that would scarcely have been known, and probably never remembered, save in their immediate vicinity, have become celebrated, and will ever be held sacred as memorable fields, where thousands of brave men yielded up their lives a willing sacrifice for the cause they had espoused.

Verbal representations of such places, or scenes, may or may not have the merit of accuracy; but photographic presentments of them will be accepted by posterity with an undoubting faith. During the four years of the war, almost every point of importance has been photographed, and the collection from which these views have been selected amounts to nearly three thousand.

On the Fourth of July, 1863, Lee's shattered army withdrew from Gettysburg, and started on its retreat from Pennsylvania to the Potomac. From Culp's Hill, on our right, to the forests that stretched away from Round Top, on the left, the fields were thickly strewn with Confederate dead and wounded, dismounted guns, wrecked caissons, and the debris of a broken army. The artist, in passing over the scene of the previous days' engagements, found in a lonely place the covert of a rebel sharpshooter, and photographed the scene presented here. The Confederate soldier had built up between two huge rocks, a stone wall, from the crevices of which he had directed his shots, and, in comparative security, picked off our officers. The side of the rock on the left shows, by the little white spots, how our sharpshooters and infantry had endeavored to dislodge him. The trees in the vicinity were splintered, and their branches cut off, while the front of the wall looked as if just recovering from an attack of geological small-pox. The sharpshooter had evidently been wounded in the head by a fragment of shell which had exploded over him, and had laid down upon his blanket to await death. There was no means of judging how long he had lived after receiving his wound, but the disordered clothing shows that his sufferings must have been intense. Was he delirious with agony, or did death come slowly to his relief, while memories of home grew dearer as the field of carnage faded before him? What visions, of loved ones far away, may have hovered above his stony pillow! What familiar voices may he not have heard, like whispers beneath the roar of battle, as his eyes grew heavy in their long, last sleep!

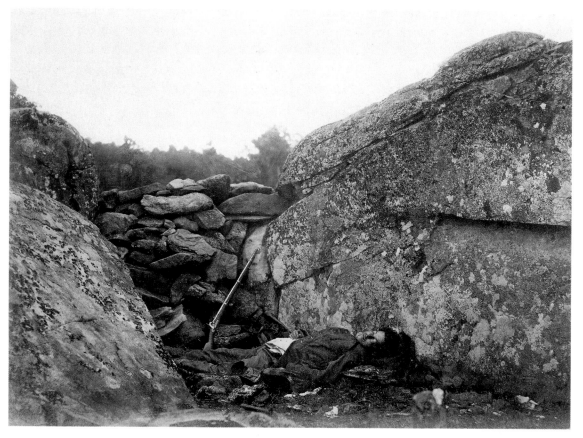

Home of a Rebel Sharpshooter, Gettysburg, July 1863
from *Gardner's Photographic Sketch Book of the War,* 1866
Albumen print
6¾ x 8⅞ inches
Purchase, partial gift of Carol L. Kaufman and Stephen C. Lampl
in memory of their parents Helen and Carl Lampl, 91.23.41

Thomas Roche
American, ?–1895

Roche was primarily known for his Civil War photography. By 1862, he had become part of the photographic team of Anthony & Co., and was traveling with the Union Army. He was among the first to photograph in the occupied cities of Petersburg and Richmond, Virginia. Roche was a prolific maker of landscape views and spent much of the 1870s photographing throughout California and the South. This description of Roche's working methods is excerpted from "Landscape and Architectural Photography," which was published in the September 1873 issue of *The Philadelphia Photographer:*

For general outdoor photography it will be necessary to have plenty of lenses, and the most improved camera box. Attempting to do work of all kinds with a single lens and an old-fashioned box will not answer. For instance, with an old-fashioned rigid, portrait camera box and a 4-4 portrait tube, trying to take a view of a five or six story building in a narrow street, or a view of a fine dwelling inside of a row of trees, the front of the camera not sliding up and down, the box has to be pointed upwards at a sharp angle, and the result is a picture without parallel vertical lines. No wonder that customers complain that there is something wrong, or, as one remarked to me, that his house looked as if all his cider barrels in the cellar had burst, and the picture was taken as the house was going over. Another instance I have seen this summer, viz., a professional photographer taking stereoscopic views with a rigid portrait box cocked up as usual and but one lens. This mode is, I believe, about the first used in making stereoscopic views, but has been long discarded for the twin tubes.

In going but a short distance from home, you will only require a dark box or tent with all necessary chemicals, camera, tripod, and negative box; but for an extended trip you will need a chemical box or miniature stock depot, divided up into square compartments, to pack your bottles and extra stock in, as on railroads they are handled rather roughly. In travelling over mountains on mule-paths, you will require boxes long and narrow. They can be packed readily on each side of the mule, and can be well tied, so that, in case the mule should roll over, he cannot hurt anything. It is always best to make out a careful list of everything needed, for if you wish to do good work, go prepared for it — do not begin to make excuses about this or that article. Take all inconveniences you may meet with in good part, and keep your temper and powder dry. It is better, if you have the time, to reconnoitre the place on some day previous to working. Pick out your standpoints, and look out for what will make good stereo views and 8 x 10 or larger sizes; mark down the time of day the light is most suitable.

My latest mode of working is to give a good exposure for details; and, in developing, get out all you can, but do not overexpose or develop so as to get a foggy or flat negative. For general work a well-lighted picture will not require, if your chemicals are in good working condition, any redeveloping or intensifying, by using Anthony's new negative collodion.

Some of our best landscape photographers have been for some time developing in the field, and finishing up at home in the evening or next morning.

If the above may be of some benefit to those who are working in the field by the wet process, I shall be abundantly rewarded.

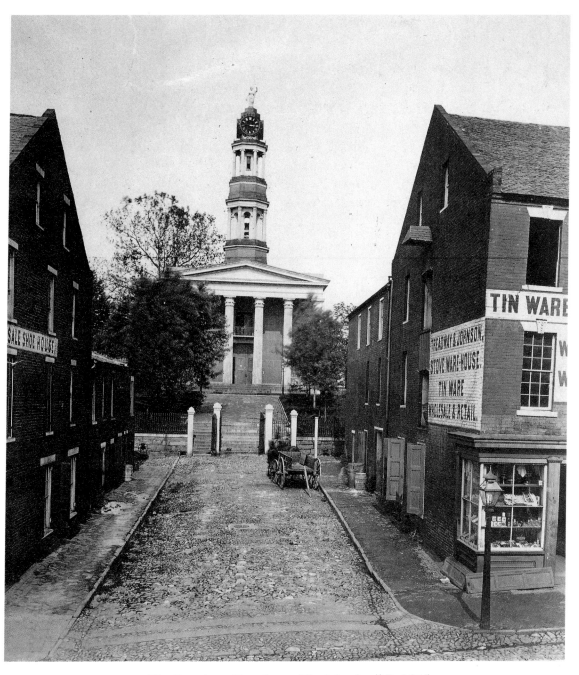

The Petersburg Courthouse, Virginia, April 3, 1865
Albumen print
10 x 8⅜ inches
Horace W. Goldsmith and Art Purchase Funds, 93.19.6

William Bell
American (b. England), 1830–1910

After operating a daguerreotype studio in Philadelphia, Bell joined the Union Army in 1862. In 1865, he was appointed chief photographer for the Army Medical Museum in Washington, D.C., where he documented the injuries suffered by Civil War soldiers. In 1872, he accompanied Lieutenant George M. Wheeler on a geographical survey west of the 100th meridian for the War Department. In the January 1873 issue of *The Philadelphia Photographer,* Bell published "Photography in the Grand Gulch of the Colorado River" which comments on his arduous trek:

Since my last communication to you I have had some rough experience in this far western country, where few white men have trod, and where the camera never before perhaps has had a "shot" at the wild beauties about us.

I will give you a little idea of our routine work, day by day, that you may know that it is not all ease and comfort.

I arise at 4 A.M.; feed the mule; shiver down my breakfast; mercury at 30 degrees, candle dim, cup and plate tin; my seat, the ground. After breakfast I roll up my bedding, carry it up to the property line to be loaded on the pack mule, water and saddle my riding mule, and by that time it is broad daylight. If negatives are to be taken on the march the photographic mule is packed with dark-tent, chemical boxes and camera, and out we start ahead of our exploring party on the lookout for views.

Having found a spot from whence three to four can be had, we make a station, unpack the mule, erect the tent, camera, &c. The temperature has risen from 30 to 65 degrees. One finds difficulty in flowing a 10 by 12 [inch] plate with thick enough collodion to make a sufficiently strong negative without redevelopment, and to have a plate ready for development that has not dried, on account of the distance the plate has been carried, and time intervening between sensitizing and development.

These troubles are constant, with occasional gusts of wind and fine white alkali dust, which often covers the plate, while being coated with collodion, as though it had been sifted on it from a dredging-box. Excepting these difficulties, along with the precipitation of half the iron in solution by the addition of the alkaline water (most met with), everything may be said to work as smoothly as could be expected under the circumstances, but the ultimate inspection of the now dried negatives is most disheartening.

They are covered with dust and sand. A blender is used to remove most of it, and the negative is varnished and packed up. Having got all we can here, everything is repacked. Meantime the whole party have passed on and are several miles ahead.

We start again, and repeat our work at another station, which, when done, brings us late in the day, and from eight to ten miles in the rear of the main party. We endeavor now to reach camp in good season, but it is generally about dark and very cold. Arriving in camp, we water, unsaddle, and feed the mules; then to supper; and, if it is not one's turn on guard, make our bed and retire, with our loaded carbine and pistol handy.

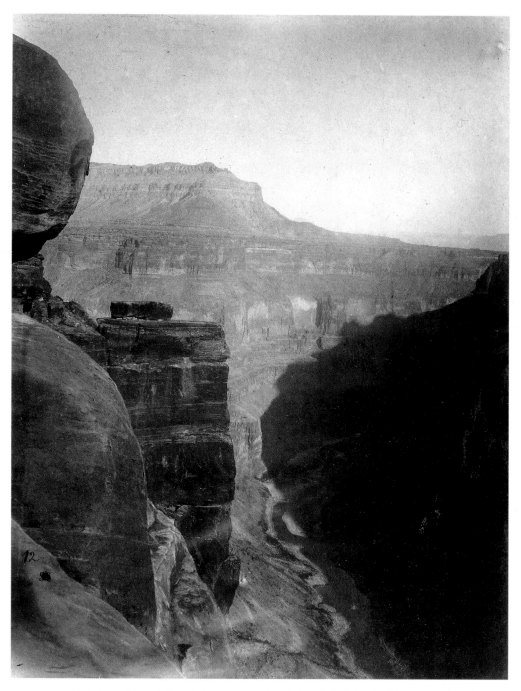

Grand Cañon of the Colorado River, mouth of Kanab Wash, looking east, 1872
Albumen print
11 x 8 inches
Horace W. Goldsmith Fund, 84.271

Timothy H. O'Sullivan
American, 1840–1882

After learning his trade while working in Mathew Brady's New York studio, O'Sullivan became one of the most prolific photographers of the Civil War. Later, he worked as a photographer on geological and mapping expeditions in the American West and Panama. O'Sullivan made more photographs of Shoshone Falls than of any other single subject, visiting in 1868 and 1874. Using John Samson as his pen name, O'Sullivan published an article in *Harper's New Monthly Magazine*. Following is an excerpt from that 1869 article in which O'Sullivan expounds on the sometimes adventurous nature of photography and the resultant rewards:

Places and people are made familiar to us by means of the camera in the hands of skillful operators, who, vying with each other in the artistic excellence of their productions, avail themselves of every opportunity to visit interesting points, and take care to lose no good chance to scour the country in search of new fields for photographic labor.

During our late war we had photographic representations of battle-fields, which are now valuable as historical material, both for present and for future use.

The battle of Bull Run would have been photographed "close up" but for the fact that a shell from one of the rebel field-pieces took away the photographer's camera. In 1863, while photographing Fort Sumter and the Confederate batteries in the vicinity of Charleston, a courageous operator saw his camera twice knocked over by fragments of shell, his camera-cloth torn, and the loose white sand of Morris Island scattered over plates and chemicals. The veteran artillerists who manned the battery from which the views were made wisely sought refuge in the bomb-proofs to secure themselves from the heavy shell fire which was opened upon their fortification; but the photographer stuck to his work, and the pictures made on that memorable occasion are among the most interesting of the war. Many of the best photographs of events that occurred during the war were made by the adventurous artist who now furnishes pictures of scenes among the High Rockies, and narrates the adventures incident of the long journey during which the photographs were made.

The volume of water pouring over the Shoshone Falls is small compared with the great flood which gives grandeur to Niagara. Neither is the width of the river greater than that portion of Niagara known as the American Fall. In the Shoshone we have fall after fall to view as a preliminary exhibition. Each cascade is a splendid fall of itself, and the vast walls of rock are worn into weird forms by the constant action of rushing water.

The surroundings of the main fall are such that any number of views may be had of the scene. Standing upon the craggy rocks that jut out from and form the walls of the tableland below the falls, one may obtain a bird's-eye view of one of the most sublime of Rocky Mountain scenes....

There is in the entire region of the falls such wildness of beauty that a feeling pervades the mind almost unconsciously that you are, if not the first white man who has ever trod that trail, certainly one of the very few who have ventured so far. From the island above the falls you may not see the great leap that the water takes, but you will certainly feel sensible of the fact that you are in the presence of one of Nature's greatest spectacles as you listen to the roar of the falling water and gaze down the stream over the fall at the wild scene beyond.

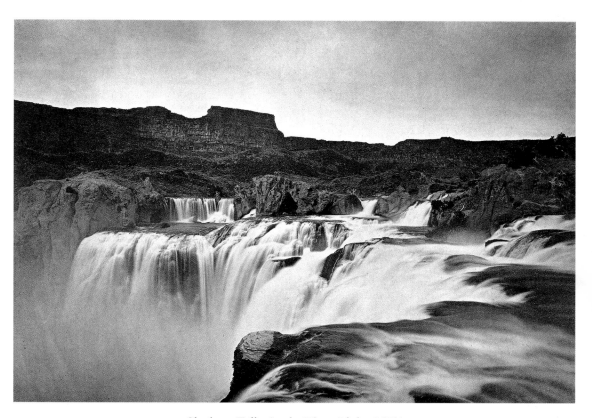

Shoshone Falls, Snake River, Idaho, 1874
from Wheeler Survey West of the 100th Meridian
Albumen print
11 x 14 inches
Horace W. Goldsmith Fund, 90.63

Julia Margaret Cameron
British, 1815–1879

Born into a prominent British family, Cameron lived much of her life in India. However, she did not begin her photographic careeer until the age of forty-eight, after receiving a camera from her daughter. Cameron knew and photographed many of the famous creative individuals of her time, among them Frederick Watts, Dante Gabriel Rossetti, Sir John Herschel, and Charles Darwin. In 1874 Cameron created illustrations for Alfred Lord Tennyson's *Idylls of the King and other Poems.* Her soft-focus style was caused by long exposures, which she believed allowed more of the true personality of the sitters to reveal itself. This somewhat whimsical text, entitled "The Annals of My Glass House," was first published in *Photo Beacon* in 1890:

I longed to arrest all beauty that came before me, and at length the longing has been satisfied. Its difficulty enhanced the value of the pursuit. I began with no knowledge of the art. I did not know where to place my dark box, how to focus my sitter, and my first picture I effaced to my consternation by rubbing my hand over the filmy side of the glass.

I turned my coal-house into my dark room, and a glazed fowl-house I had given to my children became my glass house! The hens were liberated, I hope and believe not eaten. The profit of my boys upon new laid eggs was stopped, and all hands and hearts sympathised in my new labour, since the society of hens and chickens was soon changed for that of poets, prophets, painters and lovely maidens, who all in turn have immortalized the humble little farm erection.

I believe that…my first successes in my out-of-focus pictures were a fluke. That is to say, that when focussing and coming to something which, to my eye, was very beautiful, I stopped there instead of screwing on the lens to the more definite focus which all other photographers insist upon.…

Artists, however, immediately crowned me with laurels, and though "Fame" is pronounced "The last infirmity of noble minds," I must confess that when those whose judgment I revered have valued and praised my works, "my heart has leapt up like a rainbow in the sky," and I have renewed all my zeal.

Personal sympathy has helped me on very much. My husband from first to last has watched every picture with delight, and it is my daily habit to run to him with every glass upon which a fresh glory is newly stamped, and to listen to his enthusiastic applause. This habit of running into the dining-room with my wet pictures has stained such an immense quantity of table linen with nitrate of silver, indelible stains, that I should have been banished from any less indulgent household.

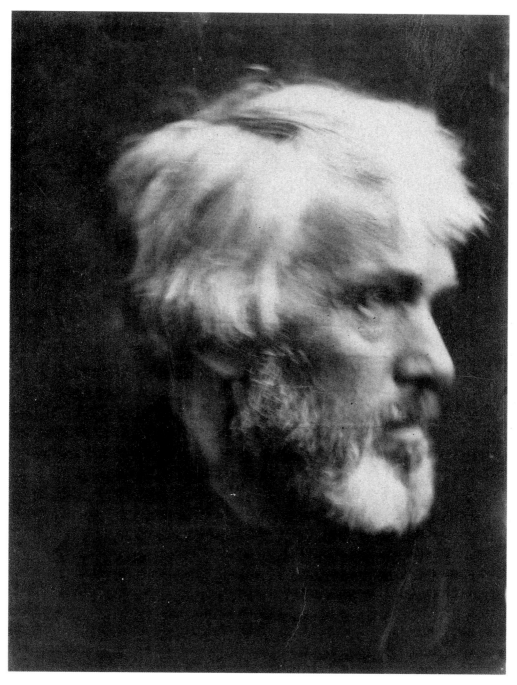

Thomas Carlyle, 1867
Albumen print
12⅛ x 9¾ inches
Gift of Mrs. Louis I. Jaffé, 50.45.6

Étienne Carjat
French, 1828–1906

In addition to his talents as a caricaturist, journalist, and editor, Carjat was a popular French portraitist who photographed many of the artistic and literary personalities of his time. He opened a studio in 1860 and continued to photograph through 1875, contributing his images to periodicals and publications such as the *Galerie Contemporaine*. Carjat's cartes-de-visite and albumen portraits were noted for their directness; this ability to capture the essential characteristics of his sitters may be attributed in part to his skill as a caricaturist. "The Lament of the Photographer," written in 1875, reveals Carjat's sardonic view of photography as a life's work:

More than six months my friend
I have been waiting for you in vain.
I dream of beautiful days gone by,
They so swiftly flew by....

What has happened, pray tell?
A new Delilah, a new belle?
Are you under some spell?
Who might this woman be, do tell!

Could she be angel, or could she be demon?
Is her hair fair, or is she darker?
Goes she to Mabille or to sermon?
Is she in money or is she a pauper?

And you, bright chameleon
Will your heart finally change color?
Will you follow our Leon later
Down the aisle to the altar?

I want to know, dear wanderer
Tell me what is the matter?
What has made you pounce and leap?
Was it riches and gold to reap?

Are you now investing?
Is a Rothschild helping?
Have you turned magic banker
Making shares higher and lower?

Must be brewing some liqueur
To make chilblains better

Or cooking up some lotion
That will grow hair to perfection.

Is it money you are seeking?
Do you want to stop painting?
Put that big lens away?
'tis only torture, I say!

Those two lenses of crystal
Inside that long tube of copper
Will lead you straight to hospital
Don't you follow me there, ever!

Become a spy or a clerk in court
Tamer of bears, wrestler, a circusman in short,
If in some attic you won't be put away
Still waiting for the money.

Be a Quaker or a Mormon.
Support the Emperor.
Don't be a photographer, ever
For 'tis worse than hard labor.

The photographer my dear Ernest
Is like a pariah at best.
He is a leper, he is Saint Genest.
Men flee from him like a pest.

And you cold-hearted being,
Through your life you go floating.
Uncaring, you go your merry way
With not even a look in my door way.

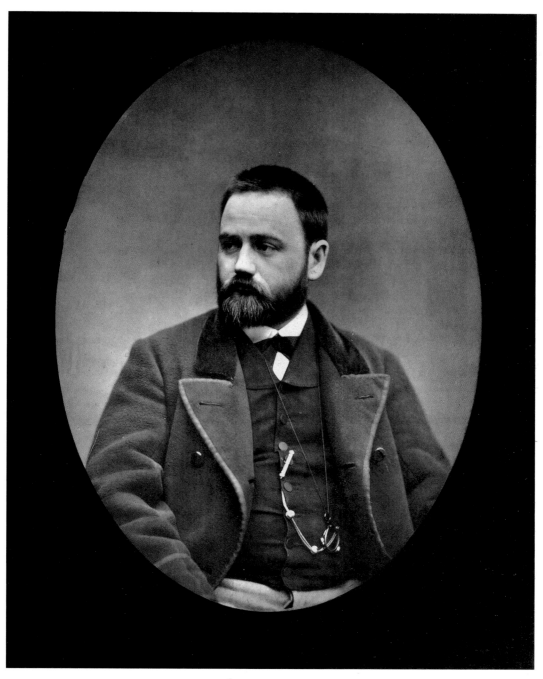

Émile Zola, 1875
Woodburytype from the *Galerie Contemporaine,* 1877
8¾ x 7¼ inches
Horace W. Goldsmith Fund, 83.225

Frank Meadow Sutcliffe
British, 1852–1941

Sutcliffe opened a portrait studio in the late 1870s in Whitby, England, where he lived until his death in 1941. Fascinated by photographic technology such as the new Kodak cameras, he experimented with many different printing processes, including albumen, platinum, and silver. Although he earned his living as a commercial photographer, he is best known for his personal work, which reflects the influence of Peter Henry Emerson in its choice of village life as subject matter and its spontaneous, naturalistic style. The following text is excerpted from a paper entitled "How to Look at Photographs," which Sutcliffe read before the Photographic Convention of the United Kingdom in 1892:

Photographs are generally said to show either technical or artistic excellence. Sometimes both qualities are visible in the same piece of work, sometimes they are not. There is another quality which ought to be present in all photographs without which no photograph can be considered perfect; and, until this quality has been recognized, the photographer should stop before he pats himself on the back and says, "What a good boy am I," after he has taken what he may look upon as a perfect piece of work, as an example of technical skill or an attempt at picture-making; it may be clever, yet for all that it is a failure if it cannot speak to those who look at it.

There has been, as you all know, a lot of strife between what has been called the old school and the new, and the sharp and the unsharpened; it seems to me that, if both these parties had looked at their work and at that of others in the right way, all this bickering would not have been. It would almost appear as if many consider their photographs as an end rather than a means to an end, and as if all that is expected of the spectator is that he should admire the skill of the worker as shown in his work; sometimes even it appears to be the author of the work who expects to be admired.

The person who looks at a photograph as a complete picture, unable to say anything about anything except the facts which existed at the moment of exposure, does not see very far. You may contend that, if this is true, it will depend more upon the spectator than upon the photograph, for what will give pleasure to one will say nothing to another. To be sure if the spectator is blind to everything except the mechanical part of the work, the loss is his alone; but he need not, as he often does, call attention to his own ignorance by denouncing a picture a failure because his mind happens to be blank except so far as a knowledge of a certain kind of mechanics may go.

If a photographer thinks he can tell his tales better by making his works microscopically sharp, let him do so by all means; if any one's hobby is the study of mosses and fungi, no pinhole or spectacle-lens view will remind such a one of the happy days he has spent in pouring over damp walls in musty nooks and corners. To some an extremely sharp picture may be positively painful, for it will perhaps disturb and break the train of thought, whereas a less-defined one would allow the mind to wander at its own sweet will.

May I say that a photograph gives us the naked truth, which has to be clothed by the imagination.

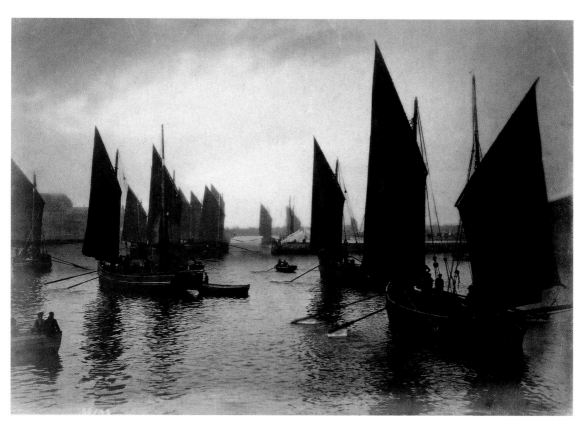

Harbor View, ca. 1880
Albumen print
5¾ x 8 inches
Horace W. Goldsmith and Art Purchase Funds, 85.155

Henry Peach Robinson
English, 1830–1901

Arguably, Robinson was the most widely-known photographer of the latter half of the nineteenth century. His method of working required assembling many negatives to create a seamless image that could be viewed and regarded using the same criterion as was used for academic painting. A prolific writer, he authored several volumes on the merits of pictorial photography, primarily treatises on technical aspects. This passage, which comes from his 1896 book *The Elements of a Pictorial Photograph,* discusses the merits of photography as art:

Photography is becoming so very useful that it is a question whether it will not in time be forgotten that it was originally intended as a means of representing the beautiful, and become known only as being the humble helper in everybody's business except its own, from that of the astronomer, who uses it to discover unsuspected worlds, down to that of the "brewer and baker and candlestick maker." It may be said that there is scarcely anything our art cannot accomplish, even to seeing things invisible to ordinary senses and photographing the living bones of which our frames are made. The only impossibility to the art — if we are to believe some art critics who appear to have had little opportunity of observation — is that it can produce art; this little treatise contends that the camera is only a tool in the sense that the brush is a tool, and one capable in the hands of an artist of conveying thought, feeling, expressing individuality, and also of the usual attributes of art in their degree.

From the earliest times photography was intended to produce pictorial results. The first photographers devoted all their attention to making pictures, and there has always been a few who have endeavoured to keep the sacred lamp of art alight, but the adaptability of the processes to every purpose under the sun, has interfered greatly with its fitness for finer issues. Another cause of decadence has been the curious fondness of the public for meretricious untruthfulness, such as mistaking smoothness and polish for beauty, and venerable wrinkles for ugliness. Still another, and perhaps the chief cause, is that there are many men who can understand an obvious fact to one who has a feeling for the sentiment of beauty. The former find that the hard nuts of science (whether they crack them or only break their own teeth) easily satisfy their aspirations, and at the same time they cannot feel much conviction about a thing they so little understand as art. The efforts, however, of the promoters of the Photographic Salon during the later years, have met with very great success in inducing photographers and the public to take a more serious view of the art.

This is not intended to be so much a serious treatise on art, as a book of hints and suggestions supplementing, but distinct from, a former volume — *Pictorial Effect in Photography.* I want to help the amateur to recognise that there is much more in the art than the taking of a simple photograph, that its materials are only second in plasticity to those of the painter and draughtsman, and that if they are more difficult to manage, there are effects to which they are even more adapted than any other means of art. Much of the volume will be found useful for suggesting subjects which are possible to those means.

When The Day's Work Is Done, 1890
from *Sun Artists,* January 1890
Photogravure
5⅞ x 7⅛ inches
Horace W. Goldsmith and Art Purchase Funds, 93.19.5d

Thomas Eakins
American, 1844–1916

Best-known as a painter, Eakins made photographs primarily for his own enjoyment, although some were used as documents and studies for his paintings. He was very interested in the study of anatomy, and was excited by the motion analysis photographs of Eadweard Muybridge. Eakins's photographs date from the 1880s to around 1900, and consist mainly of family snapshots, portraits, genre scenes, and images of moving people and animals. While living in Europe, Eakins wrote a letter to his father in which he discusses his thoughts on the creation of art. This text is excerpted from that letter:

The big artist does not sit down monkey-like and copy a coal-scuttle or an ugly old woman like some Dutch painters have done, nor a dung pile, but he keeps a sharp eye on nature and steals her tools. He learns what she does with light, the big tool, and then color, then form, and appropriates them to his own use. Then he's got a canoe of his own, smaller than Nature's, but big enough for every purpose.... With this canoe he can sail parallel to Nature's sailing. He will soon be sailing only where he wants to....but if ever he thinks he can sail another fashion from Nature or make a better-shaped boat, he'll capsize or stick in the mud, and nobody will buy his pictures or sail with him in his old tub.

The big artists were the most timid of themselves and had the greatest confidence in Nature, and when they made an unnatural thing they made it as Nature would have made it, and thus they are really closer to Nature than the coal-scuttle painters ever suspect. In a big picture you can see what o'clock it is, afternoon or morning, if it's hot or cold, winter or summer, and what kind of people are there, and what they are doing and why they are doing it. The sentiments run beyond words. If a man makes a hot day he makes it like a hot day he once saw or is seeing; if a sweet face, a face he once saw or which he imagines from old memories or parts of memories and his knowledge, and he combines and combines, never creates — but at the very first combination no man, and least of all himself, could ever disentangle the feelings that animated him just then, and refer each one to its right place....

Then the professors, as they are called, read Greek poetry for inspiration and talk classic and give out classic subjects, and make a fellow draw antique, not to see how beautiful those simple-hearted big men sailed, but to observe their mud marks, which are easier to see and measure than to understand. I love sunlight and children and beautiful women and men, their heads and hands, and most everything I see....

Hannah Susan MacDowell with the Crowell Children, Avondale, Pennsylvania, 1883
Albumen print
3½ x 4½ inches
Horace W. Goldsmith and Art Purchase Funds, 92.48

Frank Jay Haynes
American, 1853–1921

Following in the footsteps of the great recorders of the West, Haynes established a place for himself in photographic history as the photographer of Yellowstone. He built a lucrative business through the sale of mammoth-plate prints, smaller prints, and eventually, postcards to tourists. After apprenticeships in Wisconsin, Haynes began his photographic career in 1876 when he was contracted by the Northern Pacific Railroad to make views of farm life and the progress of technology along the railroad lines. In 1884, he opened a seasonal studio on the grounds of Yellowstone and spent most of the next thirty-two years preserving the wonders of the park. On August 29, 1881, Haynes wrote to Sam J. Kirkwood, Secretary of the Interior, that "I shall endeavor to illustrate this wonderland to the satisfaction of all." In the following statement to Emerson Hough, Haynes comments on the technicalities of lighting and lenses.

All amateurs…think they have to have the sun at their backs. You'll find this is wrong: if you get the sun to one side and catch the shadows, you get a "Rembrandt-lighted" picture with good contrasts. If you try to photograph a geyser in action, you get nothing with the sun at your back because there is no contrast between the steam and the background. Better squarely face the sun and the light shining in against the cloud of vapor will give you a sharp clear negative.

As to focus…with the right lens you can forget focus. My Ross lens cuts sharp and clear from twenty-five feet to half a mile and gets relative perspective. It pays to get the best lens you can afford. And don't go snapping at everything. Be patient and wait till you have a good subject.

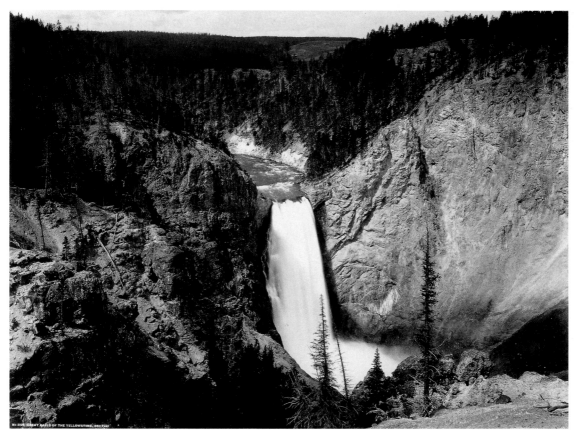

Great Falls of the Yellowstone, 1884
Albumen print
17⅛ x 21½ inches
Art Purchase Fund, partial gift of Mr. and Mrs. John F. Marshall, Jr., Mr. and Mrs. Calvin H. Childress,
Mr. and Mrs. Chris A. Crumley, Dr. and Mrs. George M. Kemp, Dr. Patricia L. Raymond, and Ms. Germaine Clair, 94.17

Adam Clark Vroman
American, 1856–1916

Born in La Salle, Michigan, Vroman began making landscape photographs upon his move to Pasadena, California, in 1892. He made his first visit to a Hopi village in 1895 and spent the next fifteen years photographing the daily lives and rituals of Native Americans throughout the southwestern United States. Unlike other photographers of his day who exploited these cultures, Vroman created thoughtful and respectful studies, in which he sought to preserve this vanishing life-style. Vroman spoke out against attempts to assimilate the Native American into mainstream culture. Vroman describes his approach to photographing Native Americans in this excerpt from an article in the February 1901 issue of *The American Journal of Photography:*

But we hasten along, making a few exposures around the pueblo and try to get acquainted with the natives. If you are a little patient and do not try to hurry matters you will have but little trouble in getting what you want. The Indian must always have plenty of time to think over anything he is to do, and you cannot rush him a particle; sit down with him, show him the camera inside and out, stand on your head (on the ground-glass) for him, or anything you want him to do, and he will do the same for you. One trouble is a lack of background if you take the time to improvise one. The subject may change his mind and your time is wasted.

Another trouble is the promises of the white man. If an Indian promises to do a thing he will do it, but we promise to send the Indian prints, little thinking how difficult it is to get them to him, if we are successful with the negative. You must arrange to send in care of some one whom you know will take the trouble to take them to the Indian. To break your word once, ends it with him. He will never overlook it, and this failure of some to keep their word has made him doubt us all.

It is much the best way to pay him at the time, and then if your negative is satisfactory, send him a print, and if you should go a second time to the same pueblo, you will find one "Quatse," at least.

I recall the past summer, sitting one evening at Capt. Keams, a young Indian kept looking at me, when suddenly he rushed up, put his arm around me, and said he was "Ongha," who I remembered five years ago at my first visit at the Moki Towns had been with me several days.

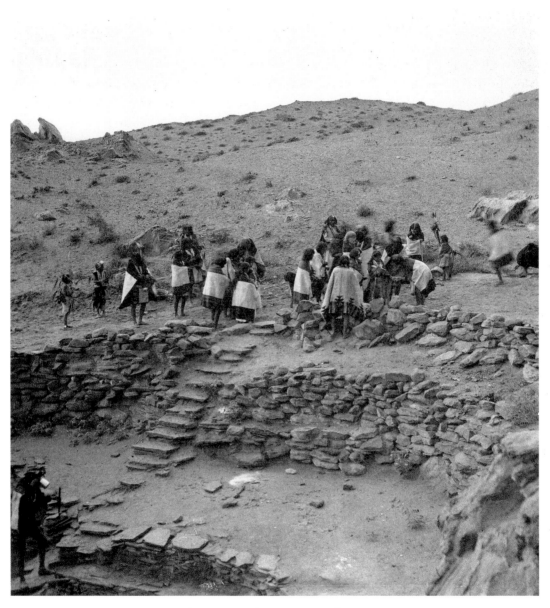

Hopi Towns, Snake Dance, Oraibe, 1898
Platinum print
6¼ x 5½ inches
Horace W. Goldsmith and Art Purchase Funds, 86.196

Edward S. Curtis
American, 1868–1952

For more than thirty years Curtis was obsessed with his comprehensive photographic documentation presenting "every phase of life among all tribes yet in primitive condition." From 1907 to 1937, he published twenty volumes of his photographs, with accompanying text entitled, *The North American Indian*. His romanticized views of Native American life have led to questions of the validity of Curtis's work as true ethnographic record. In this speech delivered at the University of Washington, Curtis tells of the difficulties he endured to perform his work:

You ask me to tell you something of my work that would be of interest to photographers. I question anything in connection with it or information in regard to it being of much help to my fellow photographers, unless it would be to convince him that his life is one of comparative ease and comfort. To begin with, for every hour given to photography two must be given to the word picture part of this record of the vanishing Indian. True, many of the hours given to the writing are those of the night time, and the light is not a 32-candle-power stand lamp, but most likely two or a half dozen tallow candles fastened with their own wax to a scrap of plate or grub box. The everlasting struggle to do the work, do it well and fast, is such that leisure and comfort are lost sight of. To the oft-asked question, "What camera or lens do you use?" I can only reply "I couldn't tell to save my soul — it is enough for me to know that I have something that will make pictures and that it is in working order." And as to chemicals, I have almost forgotten that they are a necessary part of photography. With us it is seven days in a week, twenty-four hours in each day and thirty-one days in most months. We sleep when we can't work, and here is one place where we are most particular. Our beds must be as comfortable as human ingenuity can make a camp bed, for while we do rest we want to rest well. Most likely the roof to our apartment is the blue sky dome, but to sleep in the open is real rest.

The field season of 1906 was nine months long.…We have worked with fourteen languages and no end of dialects. Our camp equipment weighing from a thousand pounds to a ton, depending upon distance from a source of supplies; in photographic and other equipment there were several 6½ x 8½ cameras, a motion-picture machine, phonograph for recording songs, a typewriter, a trunk of reference books, correspondence files covering over a year of business affairs, as being always on the move it is necessary to keep up my regular correspondence in connection with the work, its publication and the lectures all from the field. Tents, bedding, our foods, saddles, cooking outfit, four to eight horses — such was the outfit.…

Each tribe visited is a new situation to be taken up and mastered, and that quickly. Every phase of their life must be noted and, as far as possible, pictured, and the gathering of this lore, logic and myth must go hand-in-hand with the picturemaking, as without the knowledge of their life, ceremony, domestic, political and religious, one cannot do the picture work well.

How do I manage the portraits and the handling of the life? In every way. Conditions cannot be changed. I must fit myself to them. Some of the portraits can be made in my tent, which is a fair sized one made for photographic work. More are made in the open, in the soft light of the morning or in the intense glare of the midday sun. The subject secured, it matters not the time or conditions. The picture must be made.

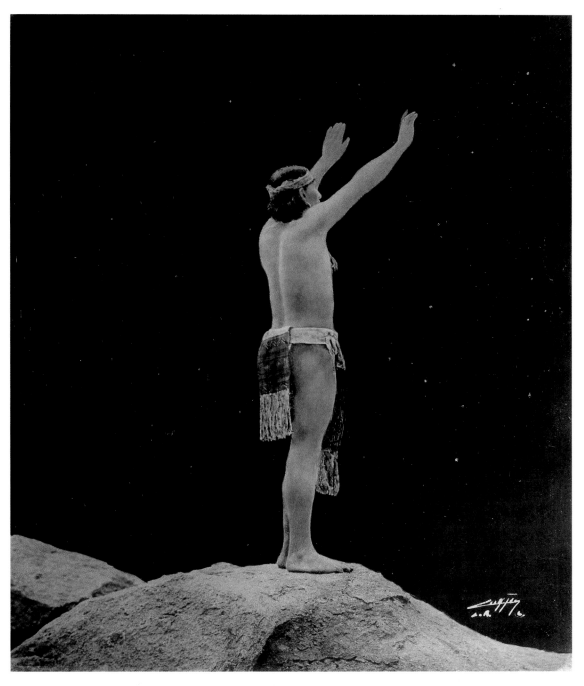

Prayer to the Stars, ca. 1909
Orotone, ca. 1916
16½ x 13⅜ inches
Gift of Robert W. Lisle, 91.114

Léonard Misonne
Belgian, 1870–1943

Misonne discovered photography while pursuing a degree in engineering, which he received in 1895. Financial independence enabled him to pursue his interests in painting, music, and photography, which he practiced exclusively beginning in 1896. By 1900, he had developed a distinctive pictorialist style, and soon gained international recognition for his atmospheric landscapes depicting the Belgian countryside. Misonne describes the importance of light for the pictorial photographer:

If I were asked what I have learned during my 40 years experience as a Photographer, I should reply:

"The most important thing I have learned is to observe the beautiful effects of atmosphere and light."

Many Photographers are concerned only with the subject and they seek to render it as it is. Often they fail to observe that the lighting and the atmosphere adorn and transform even the most humble and common-place objects.

It is the effect that should be depicted, and not the subject only. To do this successfully, the Photographer should seek continually to develop his powers of observation so that he may acquire the ability to "see" well.

These are the qualities that every successful Pictorialist must possess.

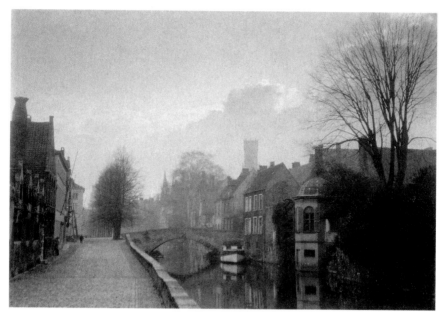

Untitled, Bruges?, after 1900
Toned silver-chloride print
3⅛ x 4¼ inches
Purchase, 83.224

Edward Steichen
American (b. Luxembourg), 1879–1973

After the first exhibition of his photographs in 1899, Steichen became a leading pictorial photographer. In collaboration with Alfred Stieglitz, he was a founding member of the Photo-Secession, was instrumental in the publication of *Camera Work,* and suggested exhibitors for the gallery known as 291. Later, he became a fashion photographer and was photographically active in both World Wars. In this text, Steichen relates his experience of making a photograph of J. P. Morgan in 1903 from which Fedor Encke was to make a painting. Obviously, this sitting with Morgan made a lasting impression on Steichen:

Morgan arrived with Encke, took off his large hat, laid a foot-long cigar on the edge of a table…and took his habitual Encke portrait pose. After a hasty look at the ground glass I said, "Still," and made the two- or three-second exposure required. Then, I took over the making of a negative for myself. I suggested a different position of the hands and a movement of the head. He took the head position, but said, in an irritated tone, that it was uncomfortable, so I suggested he move his head to a position that felt natural. He moved his head several times and ended exactly where it had been "uncomfortable" before, except that this time he took the pose of his own volition. But his expression had sharpened and his body posture became tense, possible a reflex of his irritation at the suggestion I had made. I saw that a dynamic self-assertion had taken place, whatever its cause, and I quickly made the second exposure, saying, "Thank you, Mr. Morgan," as I took the plate holder out of the camera.

He said, "Is that all?"

"Yes, sir," I answered.

He snorted a reply, "I like you, young man. I think we'll get along first-rate together." Then he clapped his large hat on his massive head, took up his big cigar, and stormed out of the room. Total time, three minutes.

Over the years people have referred to the insight into Morgan's real character that I showed by photographing him with a dagger in his hand. But this was their own fanciful interpretation of Morgan's hand firmly grasping the arm of the chair. It is not only photographers who read meanings into their photographs.

The experience of photographing J. P. Morgan taught me an important lesson. In Milwaukee, I had found that capturing the mood and expression of the moment was more important than photographing the twigs, the leaves, and the branches of the trees. And in photographing the dynamic personality of Morgan, I found that, when he sat in the pose he habitually took for the painter, all I saw was the map of his face, blank and lifeless. But when he was irritated, even by a trifle, something touched the quick of his personality and he reacted swiftly and decisively. The lesson was that a portrait must get beyond the almost universal self-consciousness that people have before the camera. If some moment of reality in the personality of the sitter did not happen, you had to provoke it in order to produce a portrait that had an identity with the person. The essential thing was to awaken a genuine response. This was one of the most valuable lessons I ever learned, and it stood me in good stead later when I worked for *Vanity Fair* and was doing portraits almost daily.

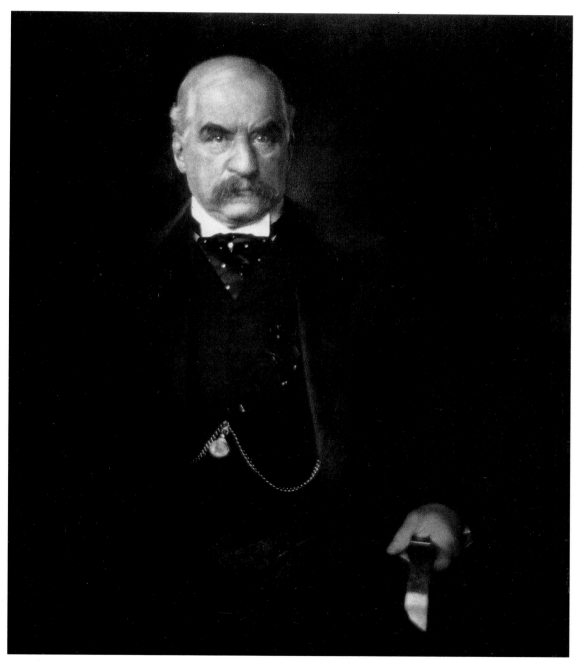

J. P. Morgan, 1903
Gelatin-silver print
16½ x 13½ inches
Gift of Walter P. Chrysler, Jr., 71.2207.41

Gertrude Käsebier
American, 1852–1934

Käsebier turned to photography at the age of thirty-six, and in 1897 opened a studio in New York where she introduced natural poses to commercial portraiture. Käsebier worked in the soft focus style of the Pictorialist movement, and was a founding member of the Photo-Secession in 1902. Käsebier is known for her photographs of womanhood and the relationship between mothers and daughters, and she did much to encourage women to pursue photography. In this 1898 passage, Käsebier speaks about her innovative approach to composition:

I feel diffident in speaking to you about photography, because I have not followed the beaten paths, and because I have had to wade through seas of criticism on account of my heretical views….

Why should not the camera as a medium for the interpretation of art as understood by painters, sculptors and draughtsmen, command respect? Why should it not be required of the photographer, desiring to be known as an artist, that he serve an apprenticeship in an art school? Masterpieces can never be understood, or appreciated, or produced by one whose sense of beauty has not been awakened and educated. There is more in art, with an apology to that much abused word, as applied to photography, than startling display lines, on mounts and signs announcing "Artist Photographer," "Artistic Photographic Studio," etc., and the lower the standard the more frantic the claim….

An artist must walk in a field where there is something more than chemical formulae, theatrical effects, affected and monotonous posing. He must see nature through the medium of his own intellectual emotions, and must guard that they be not led into artificial channels. Technique is not art, but manual skill; a proficiency of labor, which can be acquired… without a glimmer of artistic feeling….

There is, however, a growing, cultured public, whom we are bound to take into consideration. There is a far cry for more art in photography. It has to come; and it will come through the amateurs. They are not hampered by the traditions of the trade and are not forced to produce quantity at the expense of quality. They go at their work in a more natural, simple and direct way, and they get corresponding results. One of the most difficult things to learn in painting is what to leave out. How to keep things simple enough.

The same applies to photography. The value of composition cannot be over estimated; upon it depends the harmony and the sentiment. Instruments and mediums can be had for a price; originality, creative faculty, poetic feeling, can come from only one source, but they can be lost if they be not cherished….

The key to artistic photography is to work out your own thoughts, by yourselves. Imitation leads to certain disaster.

New ideas are always antagonized. Do not mind that. If a thing is good it will survive. I earnestly advise women of artistic tastes to train for the unworked field of modern photography. It seems to be especially adapted to them, and the few who have entered it are meeting with gratifying and profitable success. If one already draws and paints, so much the better the equipment. If one has wrestled with the subtle lines of the human form; if one has experienced the feeling of trying to produce color from simple pigments, their enjoyment of the exquisite pictures thrown upon the ground glass will be enhanced, and their artistic growth and color sense will not suffer.

Besides, consider the advantage of a vocation which necessitates one's being a taking woman.

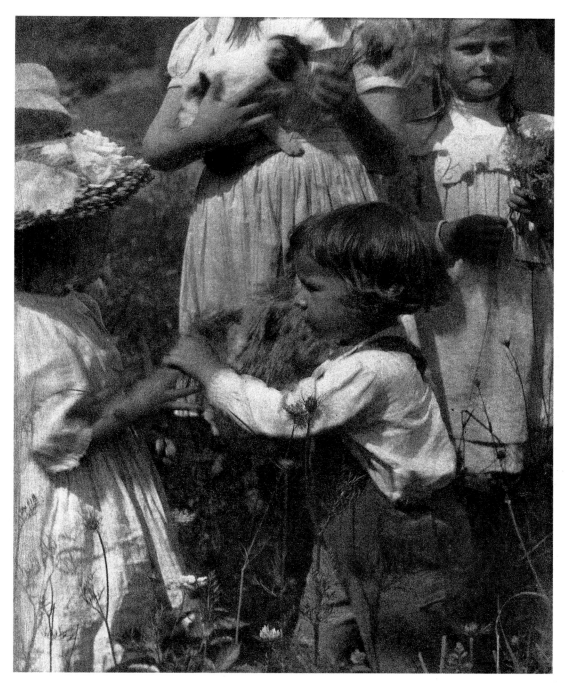

Happy Days, from *Camera Work, No. 10,* April 1905
Photogravure
8½ x 6½ inches
Horace W. Goldsmith and Art Purchase Funds, 89.111.4

James VanDerZee
American, 1886–1983

One of the first major African American photographers, VanDerZee's career spanned over seventy years. In 1907 and 1908 VanDerZee lived for a brief period in Phoebus, Virginia, where he photographed the town's activities as well as the students and teachers of Hampton Institute, an instructional school for African and Native Americans founded in the 1860s. After returning to New York, he opened Guaranty Photos in 1916, where he photographed the celebrities of the Harlem Renaissance and middle-class African Americans. A musician and self-taught artist, VanDerZee commented that music and art all seemed to work in conjunction. In the following he reminisces about the early days of photographic technology:

I was a big professor [a common title of respect for musicians] down there, and yet I was myself trying to get an education. Of course, I was never too hot at the piano or the violin, but at the same time, I was so much better than the rest. There was one professor at the school who was very good, and I couldn't understand why they thought I was so much better than he until I figured it out one day. I figured it must be that the stuff he was playing was so difficult that their untrained ears couldn't follow him. I played pieces like Ave Maria and Mendelssohn's Spring Song, simple pieces that had an even, flowing melody that was easy to follow. But he'd be playing something that would be too much for them. They could appreciate my work, so they liked my work much better….Music and art, they all seemed to work in conjunction, to my way of thinking….

We were obliged to use flash powder in those days. It produced very good illumination, but there were technical difficulties. If you put too much powder in, why, you were liable to blow your head off, or at least your hand. I knew people who got burned pretty bad. I burned my hand sometimes, trying to light the powder. Then I noticed an advertisement; it showed a tray and a partition with a hole in it, so you lighted the powder with a match that you put through the hole. I started using that. There were others where you lit the powder with a gun.

You'd open the lens of the camera, let the powder go off — bang! — and close the camera up. Course there was a great deal of smoke to it afterwards. If there was a high ceiling it was all right, because it took a little time for the powder to go up and come down. I'd try to make a second shot quick, because when all that smoke came down everyone would start coughing and choking. With a low ceiling, the powder would go up and spread around and come down, and there was no time for a second shot. We had to get out of there before they started coughing!

Some big concerns had flash bags they put the powder in, and had it connected up with electricity. Flash went off, and it wasn't so bad. Then later on, they came up with the flash bulbs and that was a great improvement. There wasn't any smoke. But with the flash powder you could make the illumination as bright as you wanted….

Being an artist, I had an artist's instincts. Why, you have an advantage over the average photographer. You can see the picture before it's taken; then it's up to you to get the camera to see it.

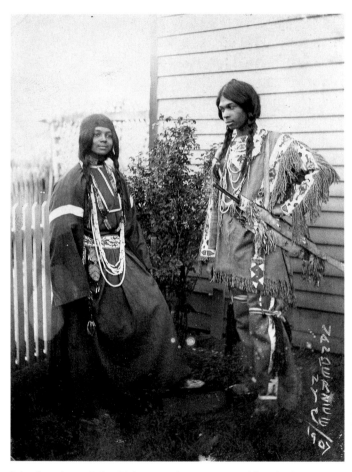

Schoolteachers, Miss Holmes and Harry McGill, Virginia, 1907
Gelatin-silver print
4⅝ x 3½ inches
Purchase, 88.66

Anne W. Brigman
American 1869–1950

Brigman was an ardent feminist who separated from her husband to seek her destiny. Best known for her allegorical nudes made outdoors in the natural environment, Brigman became a member of the Photo-Secession, and her work was published in three issues of *Camera Work*. In 1909, she spent eight months in New York, at which time she met Alfred Stieglitz at his art gallery known as 291. This text, which was published in the *Camera Work* issue "What is 291?" describes her first meeting with Stieglitz whom she refers to here as the Man, with a capital M:

Don't you remember trying, in your youth, to sit still on a haircloth sofa during long Sunday morning prayers? Of the ache in your legs for flight; of the hunger for air in your nostrils; of the wild, wonderful need to stampede?

Never mind. All this belongs to the impressions that gather themselves around those first spaces called a few minutes which were the beginnings of the real 291.

Another time, after going over many folios of photographs, my own among them, I said, I hoped when I first came, that you would show some of my things. Now I'm deadly afraid you will.

"Why?" asked the Man.

Because, I answered, the longer I look at the intelligent beauty of the work in these folios, the muddier and hotter looking my sepia bromides grow. How did you ever care to show them?

The Man's short gray moustache twitched. He shuffled reams of papers, magazines, and envelopes.

I had begun to think he hadn't heard the question, or perhaps forgotten.

Then he adjusted for the hundredth time, with thumb and finger his pince-nez glasses and glancing over the edges of them said, staccato —

"The way you did them was rotten, but they were a new note — they were worth while."

Then he walked out of the liliputian room, and I sat humped up on the arm of the big chair and stared down Fifth Avenue, trying to focus the unarrested lens of my thoughts.

"Rotten — but worth while."

I was beginning to understand!

Nothing in this place was final (nothing ever is) but things that stayed for a time were worth while....

You remember too, the long steep trails that lead zig-zag, mile after mile, away from trees and brooks, up, up into the heat of rocks blessed by the sun, where your lungs ache and your heart hurts from the struggle — and then you find it — the Vision! — the glory of the things beyond.

The memory and the wonder of it goes with you to the lowlands, into the daily life, and you are glad that you had the courage.

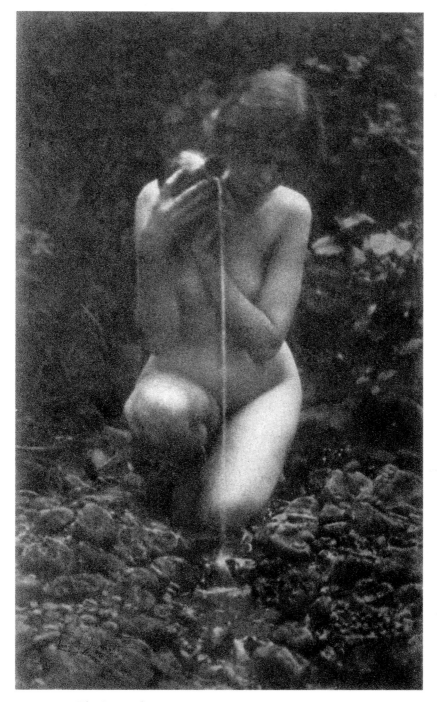

The Source from *Camera Work, No. 25,* January 1909
Photogravure
9⅜ x 5½ inches
Horace W. Goldsmith and Art Purchase Funds, 89.125.4

Clarence H. White
American, 1871–1925

Although a bookkeeper by trade, White began photographing in 1898 and soon became a widely-known pictorial photographer. In 1907 he began teaching at Columbia University and in 1914 founded the Clarence H. White School of Photography. Many of his students became well-known photographers; among them were Margaret Bourke-White, Margaret Watkins, Dorothea Lange, and Paul Outerbridge. This text is from an interview published in the *Annual Report of the Pictorial Photographers of America:*

The development of modern art, I think, is in the direction of construction; and construction, picture construction, applies to photography as definitely as it applies to painting and other art. Indeed, a great feeling of the need of this has expressed itself in connection with photography....

The rules of composition as usually understood have been too narrow. We might say there are no rules, but there are certain fundamentals. These fundamentals have been made to apply in a great variety of ways. Take this print, for instance. [Mr. White took up a photograph showing some peculiar architectural effects.] Here is a little of what we might call cubism in modern photography. We first look at it and we get pleasure from the play of light and dark on the object. It produces a sense of satisfaction to the eye, and yet when we examine it more closely we feel that the artist has violated the rules of what might be called composition. We must construct our rules of composition from examples, rather than make the construction that is demanded by our art out of formal rules....

[The photographer] should go out into the fields with an open eye and open mind to be moved to an expression of his appreciation of pattern, his appreciation of tone, of values, etc. Let him leave the mind open and that will tell him what to express. He gets his inspiration from nature and he contributes to nature just so much as he has of knowledge of photography, knowledge of composition, knowledge of tone values — he expresses himself that way. I do not believe he should go with a preconceived idea of what he is going to get. He should be moved by his subject. If he is not, he will become blind to the most beautiful aspects of nature. That is the interesting thing of nature; the changing light and shadow are never twice the same. The light is continually changing, and he has combinations and variations that a man with a preconceived idea will miss, and in photography that is the most impressive thing — that it can record these subtleties.

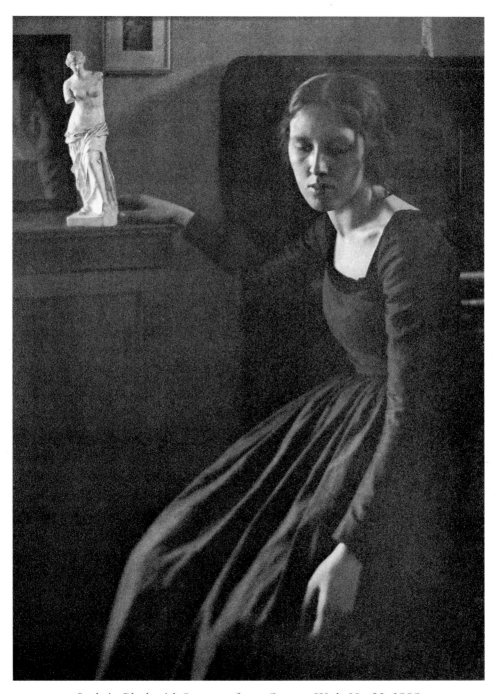

Lady in Black with Statuette from *Camera Work, No. 23,* 1908
Photogravure
7⅝ x 5⅝ inches
Purchase, 84.73.4

Margaret Watkins
Canadian, 1884–1969

Watkins began her professional career as a photographer in 1916 when she opened a studio in New York's Greenwich Village. In the 1920s she became one of the first women to be employed by a major advertising firm. A strong sense of design permeated both her personal and commercial work, transforming objects from ordinary life into abstract compositions. In this excerpt from "Advertising and Photography," published in the 1926 volume of *Pictorial Photography in America,* Watkins discussed the merging roles of artistic and commercial photography:

To fix the image projected in the camera obscura, that was a scientific problem. When it was solved we had the foundation of a new art medium. Soon Daguerre's work appeared, depicting the quaintness and decorum of our grandparents with charming precision. And D. O. Hill, seeking at first for aid in his work, became fascinated by the discovery, producing a series of portraits whose vigor and vitality hold their place today when his paintings are outdated and forgotten. Research brought technical refinements, the corrected lens, the delicate detail of the collodion plate; but when Julia Margaret Cameron photographed the celebrities of a later generation, she disdained delicacy, preferring means which gave her sitters the strength of characterization worthy of their personalities.

Then for a time force and sincerity were smothered by stilted Mid-Victorian sentiment. Landscapes were self-consciously rustic, facts obscured. Truth, acres of sweetly obvious anecdote covered the gallery walls, and photography followed the elder arts. Followed, and came to life. The ferment of the Photo-Secession seethed through the exhibitions. Repelled by the cold eye of the anastigmat, some sought to give the Impressionist sense of vibrating light, and reacted to an extreme of emotional mistiness. Others were moved by the remote aestheticism of the Pre-Raphaelites, or the fine, if somewhat conscious figure placing of Whistler; and with everyday scenes, a live realism succeeded the old deadly literalness.

And commercially? From the beginning there was a parallel and separate development. To the neat-minded scientist the accuracy of the photographic process was a god-send. Where a map of the object sufficed, here was a truthful and adequate record. Later, with half-tone, photography became the chief medium of reproduction, yet ever kept as a sedate handmaid of the graphic arts. For in the days of the Photo-Secession the artistic and commercial photographers were mutually unaware. No devout pictorialist would have deigned to descend to advertising. In their desire to establish photography as an art they became a bit precious; crudeness was distressing, materialism shunned.

With Cézanne, Matisse, Picasso, came a new approach. Soulfulness was taboo, romance derided, anecdote scorned; beauty of subject was superseded by beauty of design, and the relation of ideas gave place to the relation of forms. Weird and surprising things were put upon canvas; stark mechanical objects revealed an unguessed dignity; commonplace articles showed curves and angles which could be repeated with the varying pattern of a fugue. The comprehending photographer saw, paused, and seized his camera! And while the more conservative workers still exhibited photographs beautiful in the accepted sense, strange offerings startled the juries; prints original perhaps, but hardly pretty, and showing an apparent queerness of choice most painful to the orthodox.

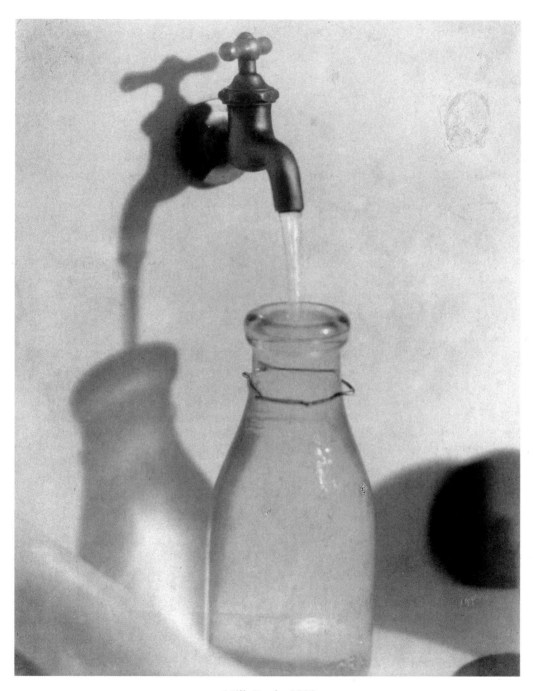

Milk Bottle, 1919
Silver-chloride print
8¼ x 6¼ inches
Horace W. Goldsmith Fund, 84.77

Alexander Rodchenko
Russian, 1891–1956

Originally trained as a painter, Rodchenko, who was active in the artistic development following Russia's 1917 revolutions, was a pioneer of new processes and ideas. Mainly self-taught, he began experimenting with photomontage in 1923, and worked as a magazine photographer and photo-reporter. His abstract images eliminated unnecessary detail and emphasized dynamic compositions; he often photographed scenes from odd angles in order to challenge the viewer's perception and delay recognition. In the following statement published in 1928, Rodchenko strongly urges his colleagues to create photographs that go beyond imitation of painting:

We struggle against easel painting not because it is an aesthetic form of painting, but because it is not modern, for it does not succeed in bringing out the technical side, it is a redundant, exclusive art, and it cannot be of any use to the masses.

Hence, we are struggling not against painting but against photography carried out according to the models of painting as if it were an etching, a drawing, a picture in sepia or watercolour.

Struggling for "what" to photograph means nothing. Examples must be provided. That is what we are all doing.

A "fact" photographed badly does not represent a cultural phenomenon, and still less a cultural value for photography....

Revolution in the photographic field consists in photographing in such a way that photography will have enough strength not just to rival painting, but also to point out to everyone a new and modern way of discovering the world of science, of technology and of everyday life....

We are obliged to make experiments.

Photographing facts as mere description is not an innovation. Behind a simply photographed fact painting can be concealed, and behind a simply described fact, a romance.

You may be advocates of the "fact," but you do not describe it so simply.

Comrades, you will soon end up confusing left and right.

A Leftist is not someone who photographs facts, but someone who, through photography, is able to struggle against "the imitations of art," with images of high quality, and to do this he experiments until he obtains a perfect "easel" photograph.

What is this easel photograph...? It is the experimental photograph.

Do not study theoretically without taking advice from those with experience and do not be the worst friends of your enemies.

For those who are doing actual work, abstract theories based on the aesthetics of asceticism are highly dangerous....

It is said: Rodchenko's photographs have become a bore: always looking down from above, looking up from below.

But everyone has been photographing "from centre to centre" for years; not just I but the majority of photographers ought to be taking pictures looking up from below or down from above....

Damn it, nobody knows what is beautiful and what is not. They do not understand new things.

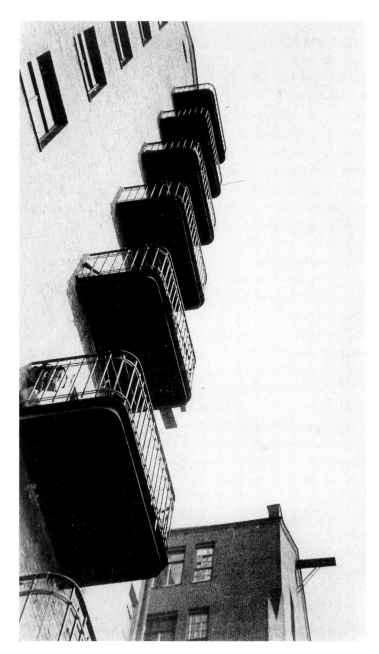

Balconies, 1925
Gelatin-silver print, 1930s
8¾ x 4½ inches
Walter P. Chrysler, Jr. Photography Fund, 95.14

Paul Outerbridge
American, 1896–1958

After training as an illustrator and painter, Outerbridge began taking photography classes in 1921. His early work consisted of still life abstractions of ordinary objects, reflecting his interest in design. By 1924, Outerbridge had become a successful advertising photographer, freelancing for *Harper's Bazaar* and *Vanity Fair*. After living and working in Paris in the late 1920s, Outerbridge set up a studio outside of New York where he experimented with carbro color photography; his mastery of this process earned him further commercial success. The following discussion on photography and still life is taken from Outerbridge's 1940 publication *Photographing in Color:*

There is always the distinction between fine and applied art to be borne in mind. Fine art exists for itself alone; applied art as an adjunct to or quality of something else — for a use, as it were. Now, whereas we do not find it hard to accept the beauty of a flower for itself alone, in present-day, mechanical-industrial civilization, people will usually question the use of a picture. Things are estimated much more for what they do or will do than for what they are or will become....

To appreciate photography one must disassociate it from other forms of art expression. Instead of holding a preconceived idea of art, founded upon painting (painting is cited because, in general, the word "art" seems to be somewhat synonymous with painting), it must be considered as a distinct medium of expression, and one must first of all realize that it is a medium capable of doing certain things which can be accomplished in no other way. No one condemns architecture because it does not look like a painting or a painting because it is not done in stone.

Of those who say that photography is too mechanical to produce works of art — and this category includes many otherwise competent art critics — it may be safely said that such an attitude denotes a lack of knowledge. The camera and the various apparatus and materials used in photography are, after all, merely tools, as are the paints, brushes, and chisels of other arts. And the result is bounded, not by the limitations of the tools, but by those of the man.

If the test of artistic worth is that an object be the means of aesthetic enjoyment, who will deny that through photography such objects may be and have been created?

Still life subjects will often reflect a clearer picture of a photographic artist's imaginative vision than landscape work, which is usually more dependent upon the choice of a point of view than upon anything else; or portraiture, in which the photographer must somewhat subordinate his own personality to that of his sitter.

Still life takes up less space and does not move; therefore less light is required. It stays where you put it, so that you can come back to it and make whatever changes in the composition or arrangement, lighting, or exposure, that you have found necessary to a better result....

What makes still life good instead of mediocre is the quality of vision and imagination employed by the photographer, and especially his reaction to his subject material. Though this subject may be, from one point of view, much more impersonal than many others, from still another viewpoint it may be intensely personal and quite a revealing expression of its creator's mind.

A sound knowledge of chiaroscuro and a passionate interest in and reaction to the shape of objects devoid of sentimental association is essential to producing the best results.

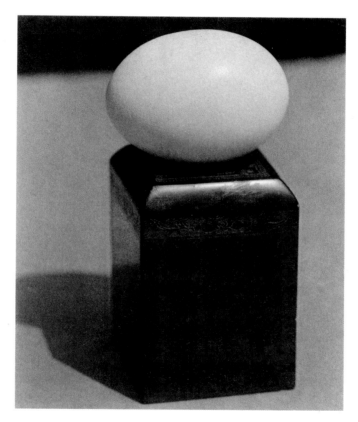

Egg on an Ebony Block, 1923
Platinum print
4¼ x 3½ inches
Robert and Joyce Menschel Fund, 80.223

Marjorie Content
American, 1895–1964

Until recently, the exquisite delicacy and formal beauty of Content's still lifes, portraits and landscapes was little known; in her lifetime, her work was published only twice and never exhibited. Although it is not certain when she began making photographs, her most ambitious work dates to the mid to late twenties, during which time she also achieved success as a costume designer. During the summers of 1931 through 1933, Content traveled throughout the southwest photographing Native Americans and making abstract landscapes. After the late 1930s she photographed sporadically, devoting most of her time to her fourth husband, writer Jean Toomer. This statement is excerpted from a journal entry dated November 18, 1936:

How to see more than one does see? Struggle with a physical object is without doubt struggle. You know it by the undeniable testimony of the strain on your muscles. It is a known experience — trying to push or lift a heavy weight. But psychological struggle is an experience not so recognizable to me. I am sure I have had it. Circumstances have produced situations against which I have struggled and also against the effects of those situations on me. But in the struggle to see more than I now see, there is nothing to come to grips with. One either can or cannot see. But what happens in that area between can and can't I do not know. It may be struggle but gives me no sensation recognizable as such. Am I struggling to extract now? I do not know.

Struggle with a particular property in oneself is more easily understandable and recognizable. It is a definite task. And progress or lack of it can be seen and measured. Progress in enlarging vision and extracting meaning could also be noticed if it were there but the way to do it is still obscure to me.

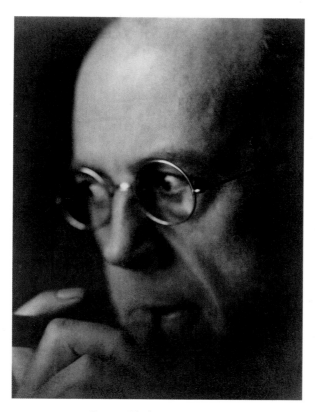

Bruce Christen, ca. 1926
Gelatin-silver print
3⅞ x 2⅞ inches
Horace W. Goldsmith and Art Purchase Funds, 93.9.2

René Magritte
Belgian, 1898–1967

A well-known Surrealist painter, Magritte began experimenting with photography and photomontage around 1929. His photographs, which can be viewed more as snapshots, document the private lives of his friends and family; however, despite their informality, it is evident that Magritte acted as director, manipulating his subjects, including himself, to create controlled compositions that often reflect the imagery in his paintings. As this statement from the 1960s suggests, Magritte regarded everyday life as the source for mystery:

Mystery — without which no world, no thought, would be possible — corresponds to no doctrine, and does not deal with possibilities. Thus, a question such as "How is mystery possible?" is meaningless because mystery can be evoked only if we know that any possible question is relative only to what is possible.

Some mediocre or absurd things do not really cast doubt on the concept of mystery; nothing beautiful or grandiose can affect it. Judgment as to what is, was, or will be possible does not enter into the concept of mystery. Whatever its manifest nature may be, every object is mysterious: the apparent and the hidden, knowledge and ignorance, life and death, day and night. The attention we give to the mystery in everything is deemed sterile only if we overlook the higher sensibility that accompanies that attention, and if we grant a supreme value to what is possible. This higher sensibility is not possible without freedom from what we call "the laws of the possible."

Freedom of thought alert to mystery is always possible if not actually present, whatever the nature of the possible: atrocious or attractive, mean or marvelous. It has power to evoke mystery with effective force.

The term Surrealism gives rise to confusion, and the term Realism is not suitable for the direct apprehension of reality. Surrealism is the direct knowledge of reality: reality is absolute, and unrelated to the various ways of "interpreting" it. Breton says that Surrealism is the point at which the mind ceases to imagine nothingness, not the contrary. That's fine, but if I repeat this definition I'm no more than a parrot. One must come up with an equivalent, such as: Surrealism is the knowledge of absolute thought.

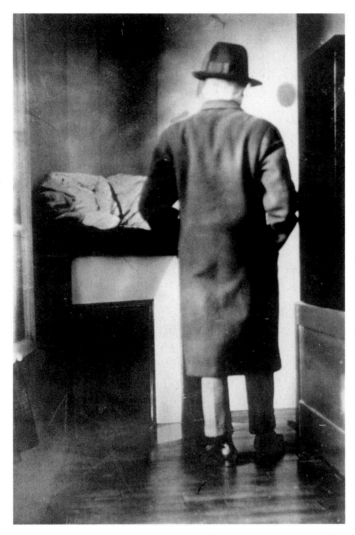

Tableau (self-portrait with Jacqueline Nonkels), ca. 1927
Gelatin-silver print
5½ x 3½ inches
Horace W. Goldsmith and Art Purchase Funds, 93.19.1

Francis J. Bruguière
American, 1879–1945

Although his earliest works reveal a pictorialist heritage, Bruguière was an instrumental catalyst in the acceptance of photography as a modern art form. He began his career as a studio portraitist in San Francisco in 1906, but after travels to Europe in 1912 and 1913, he soon recognized the abstract possibilities of photography. In the late 1920s Bruguière created a group of images called light abstractions, which captured the effects of light cast onto cut paper patterns. These images and others helped to establish Bruguière as an important contributor to the development of American Surrealism. In this 1935 statement written for *Modern Photography Annual,* Bruguière speaks of creating his own subject matter:

The application of design to the photograph is entirely in the hands of the photographer. It means that he must be equipped both technically and aesthetically. The photographer ultimately will have to be trained with as much care as those who practice the other arts. It will not be a haphazard pursuit as it is now, but will depend on the creative capabilities of the individual. Photography is not easily mastered. One's attitude to it should be one of continual questioning and dissatisfaction. Its progress depends on striving to preserve it from easy pitfalls....

It is possible for photographers to make or design objects that can be treated with light, thereby creating a world of their own which is in many ways as interesting as the visible, external world. The same laws of composition of light and shade and line govern this personal world, only it has not the so-called aspect of nature that is termed documentary.

By many practitioners of photography it is not considered "legitimate" to create a personal world: they limit the photograph to the documentary, and seem to be satisfied that it shall remain a document for ever. Human beings like to think of things in secure and proper places, to which they alone hold the key; if anyone tampers with the lock, he is a pariah! I have seen it stated by well-known photographers, and heard it from their own lips, that the photograph must be exactly the document they have defined, and that nothing else must exist in the medium!...

In making subjects of my own, I have used paper-cut designs brought into low relief, and lit, generally, by one small spot lamp of 250 watts: the same lamp has been placed in different positions through a series of exposures. The field is not limited to paper; any plastic material will answer the purpose. Then you can have the pleasure of making your own "unnatural" world, to which it is not unpleasant to return if you are a photographer, and have been working daily with fashions, portraits, or advertising!

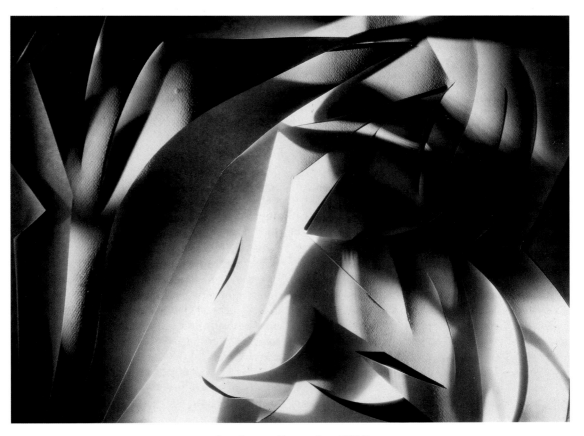

Cut-Paper Abstraction, 1927
Gelatin-silver print by George Tice, 1977
7⅜ x 9⅜ inches
Gift of George A. Tice, 91.85.3

Germaine Krull
German (born Poland), 1897–1985

Krull studied in both Paris and Munich, and received her M. A. in photography in 1918. After operating her own studio and doing freelance photography in Holland and Germany in the early 1920s, Krull settled in Paris from 1924 to 1932 where she made her reputation as a documenter of industrial architecture and machinery. During this period she also did fashion and advertising photography and created numerous portraits of her friends, including Colette and Jean Cocteau. Over the course of her long career Krull traveled widely throughout Europe and Asia and published her photographs in over twenty books. This statement, entitled "Thoughts on Art," is from a 1931 monograph, *Photographes Nouveaux: Germaine Krull.*

Photography is an artisan's field of work. A métier for which one shows more or less talent, like all craftsmanship.

Art is found in all métiers done well because art is a choice.

The most important skill of the photographer is to know how to see. Yes, one sees through one's eyes, but the same world seen through different eyes is no longer the same world; it's the world seen through that individual's eye. With just one click, the lens captures the exterior world at the same time as it captures the photographer's inner world.

The lens is designed more efficiently than the human eye. It therefore has the ability to see the world in a better light, or in a different light, which is its true function and is a pretty good one. Every new angle offers the world multiple reflections on itself.

The camera need not invent, manipulate, or fool. It does not paint, nor does it imagine. The photographer is a witness, the witness of his time. The true photographer is the witness of the everyday; he reports. That his eye does not always focus on what he sees three feet above ground is natural. But that he focuses consistently on the ground, on today's ground, on this morning's ground, on this Thursday morning's ground, or on the ground of this day so beautiful that he forgets what day it is. The world. The world of his time. And man, who has become nothing more than yet another mobile object in his world and in his time. And man, who is morally identical throughout time.

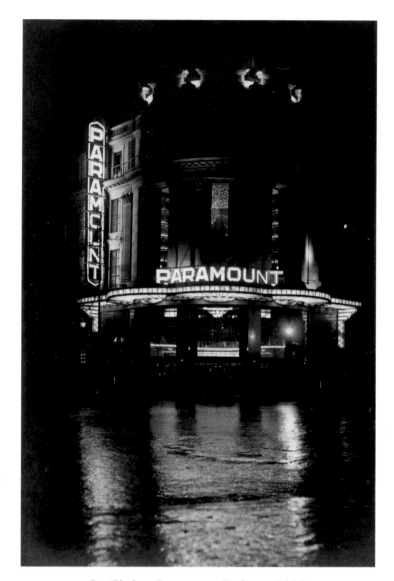

La Cinéma Paramount, Paris, ca. 1930
Gelatin-silver print
5⅜ x 3½ inches
Horace W. Goldsmith and Art Purchase Funds, 95.15.1

Doris Ulmann
American, 1882–1934

While drawn to subject matter of a documentary nature, Ulmann's consistent use of a soft focus reflects her roots in the Pictorialist aesthetic. Although a well-known portraitist of literary and medical figures, Ulmann's interest in preserving isolated cultures compelled her to travel in the 1920s throughout the rural areas of the Appalachian region. A later project to photograph African Americans in the South resulted in the book *Roll, Jordan, Roll* (1933), which discusses the lives of the Gullah people of South Carolina. Ulmann discussed her relationship with her sitters in a 1930 interview with Dale Warren, which was published in the literary periodical, *The Bookman*. This excerpt reveals Ulmann's technique of connecting with those she photographed:

The faces of men and women in the street are probably as interesting as literary faces, but my particular human angle leads me to men and women who write. I am not interested exclusively in literary faces, because I have been more deeply moved by some of my mountaineers than by any literary person, distinguished as he may be. A face that has the marks of having lived intensely, that expresses some phase of life, some dominant quality or intellectual power, constitutes for me an interesting face. For this reason, the face of an older person, perhaps not beautiful in the strictest sense, is usually more appealing than the face of a younger person who has scarcely been touched by life....

Men are usually less self-conscious and women often have preconceived notions of how they want to look. However, if a man is self-conscious he is a hundred times worse than the most self-conscious woman. Whenever I am working on a portrait, I try to know the individuality or real character of my sitter and, by understanding him, succeed in making him think of the things that are of vital interest to him. My best pictures are always taken when I succeed in establishing a bond of sympathy with my sitter. When there is the slightest suggestion of antagonism, then my best efforts are of no avail....

I see my finished print in the proof....But I cannot expect others to see anything beyond what the proof presents. I avoid retouching, but prints always require spotting before they are ready. I believe that I become better acquainted with my sitter while working at the pictures, because the various steps provide ample time for the most minute inspection and contemplation. Sometimes I wonder about thought transference. If it exists, my patients must sense my preoccupation when I think intensely of them while working on their portraits.

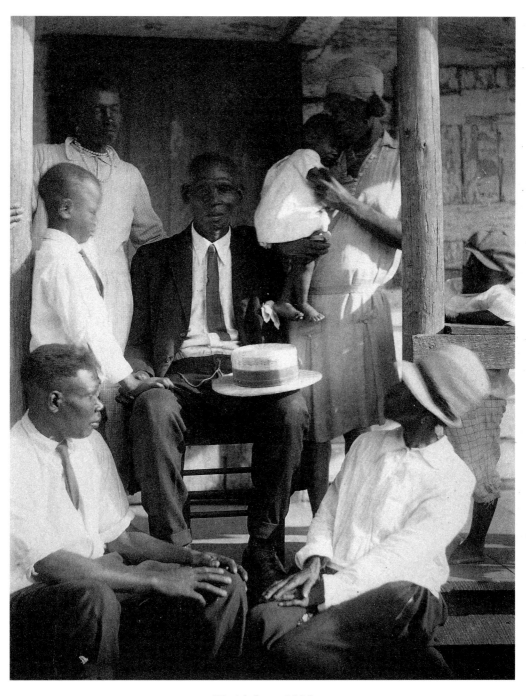

Untitled, ca. 1930
Platinum print
8⅛ x 6⅛ inches
Horace W. Goldsmith Fund, 84.176

John Gutmann
American (b. Germany), 1905–

Originally a painter, Gutmann claimed to be a photojournalist in 1933 in order to escape the German government under Hitler. Upon his arrival in the U.S., Gutmann photographed scenes of everyday life during the devastation of the Depression, as well as other troubling episodes in American history, including the National Guard occupation of San Francisco during the General Strike of 1934. Between 1940 and 1962 Gutmann's photographs were published in many magazines and periodicals, including *Life, Time,* and *National Geographic.* The following text, selected by the artist, is excerpted from a 1983 interview and from a statement written by Gutmann in 1979 in which he discusses how the interpretation of photographs is often open-ended at best:

Content to me is very important, but I like it when [the photograph] is also enigmatic. If you don't know what it is you begin to speculate, and that is what I want. I want people to be interested in my pictures, to say: "What does it mean? Is there anything else?" And I don't feel there are any absolutes in life....In my philosophy in life, everything is related to something else. Every experience is relative...which I find very exciting, because of the contrasts and affinities....

Titles or captions are important to me. I try to either state a fact of reality, give information to the curious viewer or direct attention to what the picture means to me. As a rule I do not like to explain my photographs. I want my pictures to be read and explored. I believe a good picture is open to many individual (subjective) associations. I am usually pleased when a viewer finds interpretations that I myself had not been aware of. I believe that some of my best images have this ambiguity which is an essence of life. In this sense I am not interested in trying desperately to make Art but I am interested in relating to the marvelous extravagance of Life.

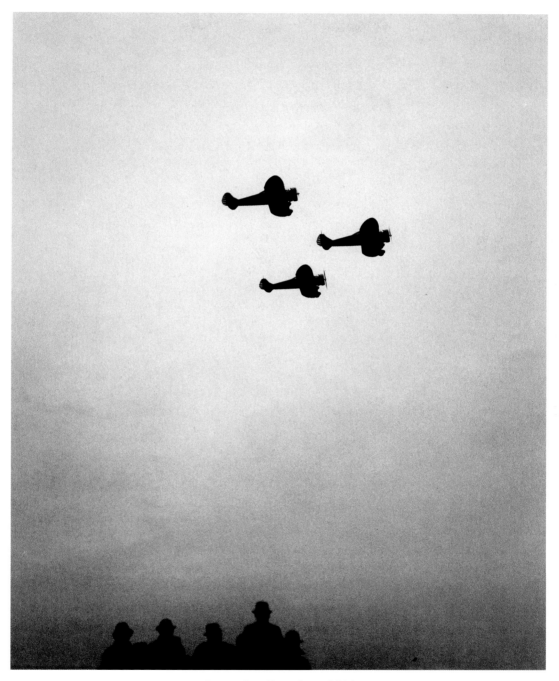

Omen, San Francisco, 1934
Gelatin-silver print
13 x 10⅜ inches
Purchase, 81.193

Margaret Bourke-White
American, 1904–1971

One of the first female photojournalists, Bourke-White's 1928 photographs of the Otis Steel Mill in Cleveland earned her a job as staff photographer at *Fortune*. In 1936, her image of Montana's Fort Peck Dam appeared on the cover of the first issue of *Life* where she was one of the original staff photographers. In 1936 and 1940 Bourke-White traveled through the South with writer Erskine Caldwell; their collaborative projects resulted in two books exploring rural life: *You Have Seen Their Faces* (1937) and *Say, Is This the U.S.A.?* (1941). Bourke-White wrote of these experiences in her 1963 autobiography, *Portrait of Myself*, from which the following reflections have been taken:

Whether he was aware of it or not, Erskine Caldwell was introducing me to a whole new way of working. He has a very quiet, completely receptive approach. He was interested not only in the words a person spoke, but in the mood in which they were spoken. He would wait patiently until the subject had revealed his personality, rather than impose his own personality on the subject, which many of us have a way of doing. Many times I watched the process through which Erskine became acquainted with some farmer and the farmer's problem.

Erskine would be hanging over the back fence, and the farmer would be leaning on his rake, the two engaged in what I suppose could be called a conversation — that is, either Erskine or the farmer made one remark every fifteen minutes. Despite the frugal use of words, the process seemed productive of understanding on both sides. While this interchange went on, I lurked in the background with a small camera, not stealing pictures exactly, which I seldom do, but working on general scenes as unobtrusively as possible. Once Erskine and a farmer had reached a kind of rapport, I could close in quite freely for portraits, and perhaps we would be invited into the tiny one-room sharecropper's home, which gave me a chance to photograph an interior.

Erskine had a gift, over and above the Southern tongue with which he was born, for picking up the shade and degree of inflection characteristic of the state in which we were working. His proficiency surprised me because he was uninterested in music. But in this he had a musician's ear. This was a useful talent in an area in which you are considered an alien and treated with appropriate distrust if you come from only as far away as across the state line. The people we were seeking out for pictures were generally suspicious of strangers. They were afraid we were going to try to sell them something they didn't want and fearful we were taking their pictures only to ridicule them. Reassuring them was a very important part of our operations, and a reassuring voice in their own mode of speech eliminated many a barrier. Of course, no amount of doctoring could disguise my mode of speech. I was unmistakably a Yankee, "down South on her vacation," Erskine would say. I could be labeled only as a foreigner, and sometimes I am afraid I acted like one....

I know of nothing to equal the happy expectancy of finding something new, something unguessed in advance, something only you would find, because as well as being a photographer, you were a certain kind of human being, and you would react to something all others might walk by. Another photographer might make pictures just as fine, but they would be different. Only you would come with just that particular mental and emotional experience to perceive just the telling thing for that particular story, and capture it on a slice of film gelatin...

Of course, I am at the very core a photographer. It is my trade — and my deep joy.

Lucky Stop Garage, 1936
Gelatin-silver print
7¼ x 9⅝ inches
Purchase, gift of Alice Frank, 95.13

Arthur Rothstein
American, 1915–1985

Rothstein began a long and prolific career in photojournalism as the first photographer hired by Roy Stryker to document the effects of the Depression for the Farm Security Administration. Rothstein's first assignment for the FSA was to photograph people who were being relocated from an area that was to become the Shenandoah National Park in Virginia. Between 1935 and 1940, Rothstein traveled to the South and the West, recording daily life in rural America. During World War II Rothstein worked for the U.S. Office of War Information and the Army Signal Corps. In 1946 he became director of photography for *Look* magazine, and by 1971 held the same position at *Parade* magazine. In a 1985 exhibition catalogue, Rothstein commented on his assignments for the FSA. This passage is part of his commentary:

You see this man in his environment and by studying the picture a little bit you get to learn a great deal about the kind of complex personality that he is. He's not just an ordinary hillbilly postmaster — he's a man who reads books as you can see by the fact that there are several books on the table as well as the one he has in his hand. He also is a religious man — you can see that by the sign "As Christ is the head of the house, the unseen guest at every meal, the silent listener to every conversation" and also he obviously has either traveled to Europe or he is familiar with places in Europe because he has a large picture of the Colosseum of Rome above the table on the wall. But then there is a frivolous side to his nature which is indicated by the coy picture of a half clad beautiful young lady hanging behind him on the wall with a party wreath thrown over it. He obviously is a man who knows how to have fun. And this man who seems to be a small town postmaster is really a complex person and you learn all of that from studying this picture....

My technical problems resulted from long periods on location, the need for high quality, and maintenance of flexibility and mobility. My first camera was the Leica. I also used the Contax, Super Ikonta B, Rolleiflex, and Linhof. I used flashbulbs to illuminate the interiors of rural homes and barns. High aperture lenses on 35mm cameras stopped action and revealed poses, expressions, and scenes that had never been recorded before. The small unobtrusive cameras made photographs possible where complicated equipment would have created antagonism. My five years with the FSA were ones of change, evolution, tension, and sometimes, frustration and despair. They were active, exciting, creative, and stimulating. During these five years, I participated in an educational experience that has influenced my life ever since.

Home of Postmaster Brown, Old Rag, Virginia, Shenandoah National Park area, October 1935
Gelatin-silver print
7⅜ x 9⅝ inches
Horace W. Goldsmith and Art Purchase Funds, 93.31.1

Dorothea Lange
American, 1895–1965

After working for ten years as a portraitist in her own San Francisco studio, Lange became disillusioned with commercial photography. In the early 1930s she turned to the streets for subject matter, photographing the effects of poverty and unemployment. From 1935 to 1942 Lange worked for the Farm Security Administration and photographed in every region of the country except New England. Lange felt strongly about photographing her subjects exactly as she saw them, and she recorded their comments as well as their gestures in order to present them as truthfully as possible. The following excerpt is from a 1952 issue of *Aperture:*

Now it is no accident that the photographer becomes a photographer any more than the lion tamer becomes a lion tamer. Just as there is a necessary element of hazard in one, in the other is a necessary element of the mechanical. For better or for worse, the destiny of the photographer is bound up with the destinies of a machine. In this alliance is presented a very special problem. Ours is a time of the machine, and ours is a need to know that the machine can be put to creative human effort. If it is not, the machine can destroy us. It is within the power of the photographer to help prohibit this destruction, and help make the machine an agent more of good than of evil. Though not a poet, nor a painter, nor a composer, he is yet an artist, and as an artist undertakes not only risks but responsibility. And it is with responsibility that both the photographer and his machine are brought to their ultimate tests. His machine must prove that it can be endowed with the passion and the humanity of the photographer; the photographer must prove that he has the passion and the humanity with which to endow the machine.

This certainly is one of the great questions of our time. Upon such an endowment of the mechanical device may depend not only the state of the present but the prospects of the future. The photographer is privileged that it is a question which in his work he can help to answer....

Yet even though we live in worlds familiar to each other, there is in the photography of how they are familiar a very special difficulty. If not by nature, then at least by tradition the artist is individual. His art, he insists, finds its expression in individuality. His gift is not that which brings together but which sets apart. But in working with a world of the familiar this is not so much so. Then the photographer must himself become a familiarity. He cannot enter the household as a man from Mars. He must, instead, become a member of the family. In order to see the familiar, he must act and feel the familiar. His impulse can be a movement of the common; his instinct can be a gesture of the ordinary; his vision can be a focus of the usual. Through his lens must be transmitted not only detail but volume; in his print must appear not only the specific but the general.

This does not mean that the photographer need make a sacrifice of his right to express himself. On the contrary, he expresses himself — perhaps more fully — in a different way. Among the familiar, his behavior is that of the intimate rather than of the stranger. Rather than acknowledge, he embraces; rather than perform, he responds. Moving in a world so much composed of himself, he cannot help but express himself. Every image he sees, every photograph he takes, becomes in a sense a self-portrait. The portrait is made more meaningful by intimacy — an intimacy shared not only by the photographer with his subject but by the audience.

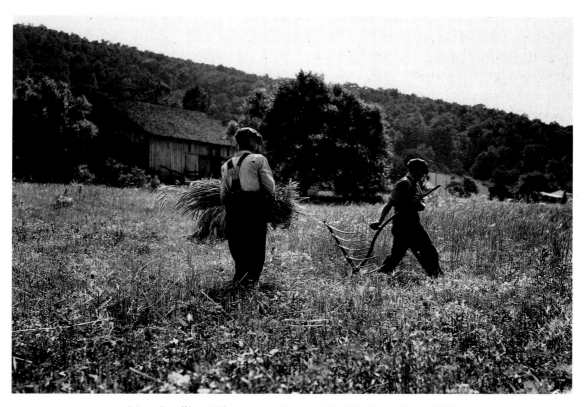

Men Cradling Wheat, near Sperryville, Virginia, June 1936
Gelatin-silver print, 1984
7⅜ x 9⅝ inches
Horace W. Goldsmith Fund, 84.78.122

Marion Post Wolcott
American, 1910–1990

Wolcott took her first photographs in 1933. Not one to be deterred by gender bias, Wolcott firmly believed that women had made great strides but still faced "formidable hurdles." In 1935 she began freelancing for *Life, Fortune,* and the Associated Press, and in 1937 and 1938 Wolcott was staff photographer for the Philadelphia *Evening Bulletin.* From 1938 to 1941, Wolcott worked for the Farm Security Administration photographing government-sponsored programs for those suffering from the effects of the Depression. Throughout her life, she was interested in exposing social inequalities, and was the first FSA photographer to contrast images of the poor and wealthy classes as a way to inform the public of the dignity and courage of the underprivileged. In the following quote, Wolcott asserts the necessity of photography as a medium for social commentary: "Speak with your images from your heart and soul. Give of yourselves. Trust your gut reactions; Suck out the juices — the essence of your life experiences. Get on with it; it may not be too late." This passage elaborates on her feelings:

My formal education had focused on child psychology. Thus, when I moved to Washington to begin the FSA job, I brought with me, not only bags and baggage, but also a significant measure of experience that definitely influenced my work — my photographs. I had warm feelings for blacks, could communicate effectively with children, had deep sympathy for the underprivileged, resented evidence of conspicuous consumption, felt the need to contribute to a more equitable society.…

As a documentarian in whatever medium, one cannot perform beyond her or his personal capacities, qualifications; of the individual's comprehension, based upon experience, research, and general ability to understand the subject and, most important, to empathize with the people directly and indirectly involved.…

My principal concern is to challenge photographers to document, in mixed media if they wish, or even just record, in still photographs as well as film and video, our present quality of life, the causes of the present malaise in our society — and the world — the evidences of it. History, which will affect this and many generations, is being made, is right out there. A record of it might help, be useful in an old, new world.…

Perhaps now, today, there is more opportunity for social commentary through photography because the scope of documentary photography has broadened, and the use of varied techniques to achieve the final image, or series of images, is widely accepted. It is no longer so controversial. It is accepted as Art. However, there are more photographers out there now who, in their earlier work, were acclaimed as Art photographers, who are focusing their cameras, eyes, talents, and interests on issues relevant to their sensitivity — contemporary issues — their special concerns aesthetically presented. Is it a symptom of a renewal of social consciousness? And, are they finally incorporating it into their concept of Art?

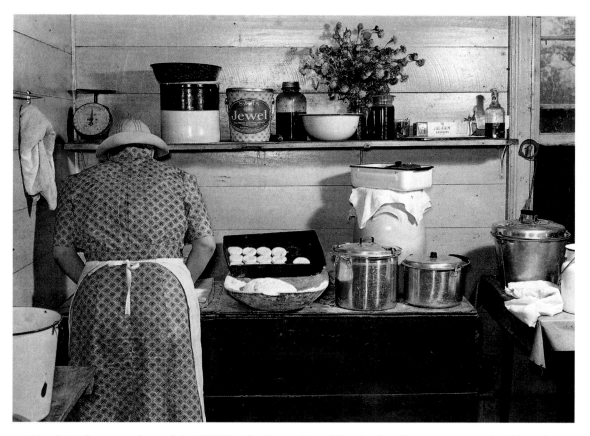

Biscuit Lady, a member of the Wilkins family making biscuits for dinner on corn shucking day
at the home of Mr. and Mrs. Fred Wilkins, near Stem and Tallyho, North Carolina, 1939
Gelatin-silver print, ca. 1984
8⅞ x 12 inches
Gift of Paul Messick Jones, 94.13

Barbara Morgan
American, 1900–1992

Originally trained as a painter, Morgan became interested in photography while teaching art at UCLA in the 1920s. She moved to New York and became an avid photographer in 1935, and throughout her career Morgan experimented with photomontage and abstraction. Best known for her dance photographs, Morgan became interested in this form of expression after observing American Indian dance rituals in the Southwest. This statement comes from a 1940 essay:

Americans dance not only with their feet and their bodies but with automobiles and airplanes. This delightful control of motion and transition of tempo gives dance sensations that are true to the American concept of freedom. Born into this love of space and movement, dance pioneers are distilling characteristic tempos and gestures out of modern life and building them into modern American dance forms. These movements are too thrilling and vital to lose, and as it is possible from the very nature of photography to capture the evanescent image of motion, I have undertaken the arduous, expensive, but engrossing work of photographing the dance.

Primarily, I am after that instant of combustion, when all the energies of the spirit are wonderfully coordinated with the action of the body. How to get that onto a negative! There is a photographic "no man's land" between a dancer's stage performance and the photographic expression of a dance that is hard to bridge. But to make a literal photograph of a dance in a bare documentary spirit is to come out empty-handed. A body in action may be calisthenics or sex appeal, but it is not necessarily dance. Something has to happen. The photograph must show an aesthetic state or the result is less than dance. On the flat, still, small rectangle of paper, how to create an illusion of a sculptural body impelled by certain emotions, moving in certain rhythmic tempo through space with convincing memorable beauty? To reach the good negative many bad ones are thrown out.

The most difficult, but also the most creative and exciting, part of dance photography is not so much the eventual picture as the groping and shaping toward a conception of what the picture ought to be. As one watches the rhythmic movements succeeding one another in time, they tend to merge in the memory — so that the memory of a dance is usually not made up of the literal moments of the dance. Therefore, to give the real essence of a dance or the real quality of a dancer, some sort of transformation has to take place before the "time" dance can become a "time-less" photograph. I have no formula for this.

Sometimes after seeing a dance in rehearsal and in performance I can visualize very clearly the photograph I want to make; the precise placing, the gradation of lights and darks, the entire expression. But when I try to execute these preconceived pictures they almost always end up as rigid lifeless images. My most fertile and rewarding manner of working is to be very familiar with the character of movement of a dancer and with the dance, until I automatically react to what is vital photographically, and reject what is insignificant. In this frame of mind, the dancer dances and always something happens which suggests a composition.

Finally, I am photographing the work of modern dancers as something organically American that must be preserved. Something as creatively of the generous American Spirit as Walt Whitman, and as inevitably a product of the forces of our continent as Rainbow Bridge or a sahuaro growing in the space of the desert.

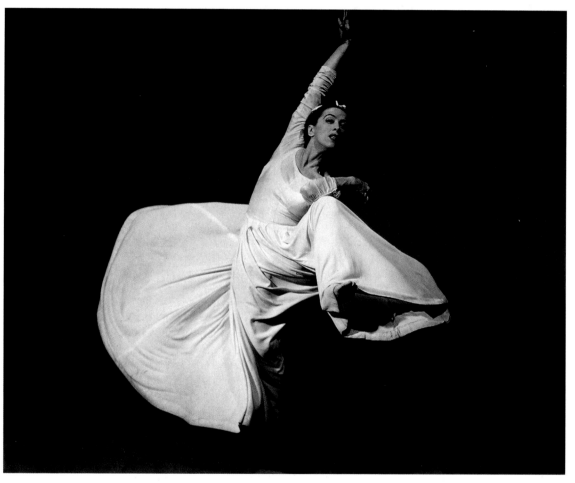

Martha Graham: Letter to the World, Swirl, 1940
Gelatin-silver print
14⅞ x 17¼ inches
Horace W. Goldsmith Fund, 86.198

Lisette Model
American (b. Austria), 1906–1983

As a young woman, Model's passion was music, but she took up photography as a way of earning a living in Paris in the 1930s. Her first major photographs were images of the wealthy taken along the Promenade des Anglais in Nice on the eve of World War II. The strength of these images secured her freelance work for *Harper's Bazaar* upon moving to New York in 1938. Model photographed life in lower Manhattan and was particularly interested in the city's nightlife; she also did several series of abstract images entitled *Reflections* and *Running Legs.* An accomplished teacher, Model defines creative photography in the following excerpt from a 1951 *New York Times* article:

To define the term creative is to define art; both words mean the same thing. If the photographer believes his print to be worthy of evaluation on artistic grounds, as one may assume all photographs are that are submitted to salons and exhibitions, then the print is by that token creative. For the only purpose of art is to be creative. If a picture is good it is creative; if it is bad, it is not creative.…

The term creative is extremely misleading. People look for creativeness either way up on ivory towers or way down in the depths of the subconscious. The fact is that creativity is just a matter of purposeful living, regardless of one's activities; anyone who achieves meaningful results is a creative person, whereas he who lives an unproductive life is not creative.

I do not believe in talent for the few; everybody has it. All depends on how much interest a person has in a specific medium, and how much effort he is willing to expend in achieving whatever goal in life he sets himself. In working with a camera, when a photographer is in contact with life and in contact with himself, that is, understands himself for what he really is, then he can use the medium creatively.…

It is of importance for photographers to realize that a photograph should be a product of today, not of yesterday. It should be concerned with everything in life that is meaningful for us today. Otherwise it is merely an imitation of something that happened yesterday, and lacks meaning today.…

A knowledge of photography in itself represents a difficult task; so-called creative photography makes it even more confusing. Let photography be the scientific eye that captures life and creates life and art. Placed between the eye of the photographer and the world, the camera reveals both man and the outside world. This in effect is the main photographic situation.

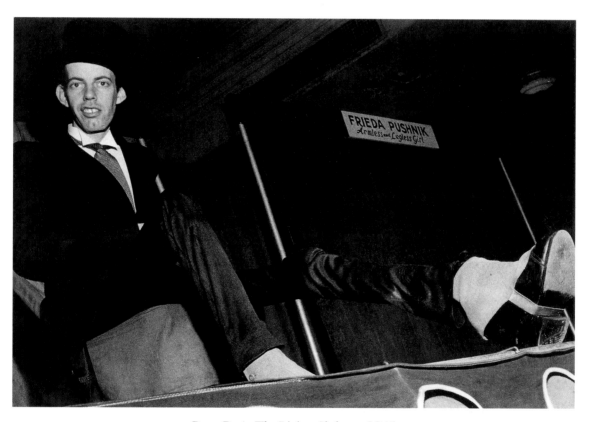

Percy Pape, The Living Skeleton, 1945
Gelatin-silver print
10 x 13¾ inches
Horace W. Goldsmith Fund, 84.33

Philippe Halsman
American (b. Latvia), 1906–1979

After operating a studio in Paris between 1931 and 1940, Halsman immigrated to America with the help of Albert Einstein, and became a freelance photographer for numerous magazines, including *Life, Time,* and the *Saturday Evening Post.* Beginning in 1942, his work graced the cover of *Life* over 100 times, more than that of any other photographer. An interest in psychology led him to focus on photographic portraiture; in his sharply focused images Halsman attempted to capture the essence of his subjects' personality. In his 1972 book, *Sight and Insight* Halsman described his sitting with Albert Einstein. This text reveals the intimacy with which Halsman approached portraiture:

If the photograph of a human being does not show a deep psychological insight it is not a true portrait but an empty likeness. Therefore my main goal in portraiture is neither composition, nor play of light, nor showing the subject in front of a meaningful background, nor creation of a new visual image. All these elements can make an empty picture a visually interesting image, but in order to be a portrait the photograph must capture the essence of its subject.

Herein lies the main objective of portraiture and also its main difficulty. The photographer probes for the innermost. The lens sees only the surface....

I admired Albert Einstein more than anyone I ever photographed, not only as the genius who singlehandedly had changed the foundation of modern physics but even more as a rare and idealistic human being....

The question of how to capture the essence of such a man in a portrait filled me with apprehension. Finally, in 1947, I had the courage to bring on one of my visits my Halsman camera and a few floodlights. After tea, I asked for permission to set up my lights in Einstein's study. The professor sat down and started peacefully working on his mathematical calculations. I took a few pictures. Ordinarily, Einstein did not like photographers, who he called *Lichtaffen* (Light monkeys)....

Suddenly, looking into my camera, he started talking. He spoke about his despair that his formula $E=mc^2$ and his letter to President Roosevelt had made the atomic bomb possible, that his scientific search had resulted in the death of so many human beings. "Have you read," he asked, "that powerful voices in the United States are demanding that the bomb be dropped on Russia now, before the Russians have the time to perfect their own?" With my entire being I felt how much this infinitely good and compassionate man was suffering from the knowledge that he had helped to put in the hands of politicians a monstrous weapon of devastation and death.

He grew silent. His eyes had a look of immense sadness. There was a question and a reproach in them.

The spell of this moment almost paralyzed me. Then, with an effort, I released the shutter of my camera. Einstein looked up, and I asked him, "So you don't believe that there will ever be peace?"

"No," he answered, "as long as there will be man there will be wars."

It is difficult for a photographer to judge the truth or the force of a photograph he has produced. I showed it first to Einstein's daughter Margot. Tears came to her eyes and she said, "I cannot tell you how much this portrait moves me." The professor was more detached: "I dislike every photograph taken of me. However, this one I dislike a little bit less."

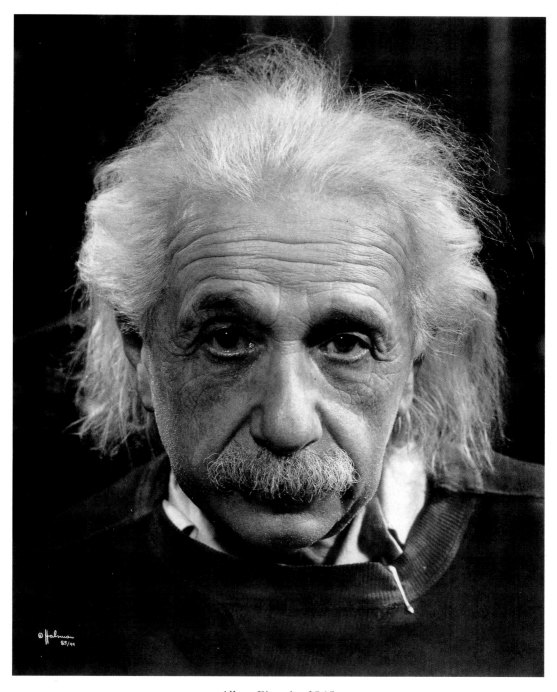

Albert Einstein, 1948
Gelatin-silver print
20 x 16 inches
Gift of Joyce and Robert Menschel, 89.94

Ralph Eugene Meatyard
American, 1925–1972

Meatyard became interested in photography in the 1950s while living a relatively isolated existence in Lexington, Kentucky, where he worked as an optician. His images of people wearing masks and inhabiting decayed structures have been characterized as haunting, enigmatic and macabre. Meatyard also made abstract images, experimenting with multiple exposures and capturing blurred movement. An avid reader of modernist literature and philosophy, Meatyard occasionally collaborated with writers such as Wendell Berry; his last major project, *The Family Album of Lucybelle Crater* (1974), was based on a story by Gertrude Stein. The following comments, written for a 1962 exhibition in Boston, are as cryptic as his photographs are surreal:

From the beginnings of my participation in photography I have always felt that it was a form of Fine Art.

I have believed that we must be true to our medium. That we must know where we have been and where we are going in order to make something original out of our art.

I have always tried to keep truth in my photographs. My work, whether realistic or abstract, has always dealt with either a form of religion or imagination. In this exhibition I deal mainly with the "surreal," which I feel is the especial province of photography.

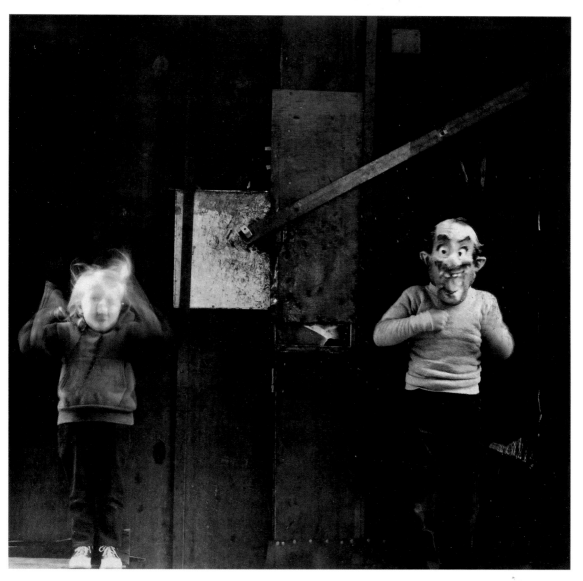

Occasion for Diriment, 1962
Gelatin-silver print
7⅝ x 7⅝ inches
Purchase, 83.614

Larry Burrows
British, 1926–1971

While Burrows covered many arenas of war in his lifetime, he is perhaps best remembered for the painterly compositions of mass, light, and shade that he made over a period of nine years in Vietnam. Although he lived and worked in the field for stretches of time, Burrows planned his images, carrying heavy loads of equipment and setting up elaborate compositions. At times troubled by the horror depicted in his often hauntingly beautiful photographs, Burrows nonetheless felt compelled to record these scenes in order to combat indifference towards and ignorance of the war's devastation. He was a staff photographer for *Life* until his death in a helicopter crash in Laos. The following statement is from a 1969 BBC-TV film on Burrows entitled *Beautiful, Beautiful:*

Do I have the right to carry on working and leave a man suffering? To my mind, the answer is no, you have got to help him....

You cannot go through these elements without, obviously feeling something yourself — you cannot be mercenary in this way because it will make you less of a photographer....

There have been moments — yes — when your lips go dry, and...anybody who does not, does not have any fear, then he is a complete idiot....

You can't go out, as you see people. A hill near the DMZ, not so long ago, when suddenly, it was just after five o'clock as a matter of fact, in came some 122 rockets. People that you had seen alive just a few minutes ago, suddenly were dead; and you realize that it could have been you....

There was one particular story which was called "One Ride with Yankee Papa 13," which involved 17 helicopters, four of which were shot down, and quite a lot of people were killed and wounded.

We tried to rescue a pilot off a ship, and we were trapped between these two 30-caliber machine guns. The VC were on the tail of the downed helicopter. We landed alongside, the co-pilot from this downed ship, wounded, climbed on aboard.

The pilot on our ship gave word for Farley, who was the crew chief, to go and rescue the pilot — who was slumped over the controls.

We could see him. Farley ran across, I ran after him, and visually — the sound of gunfire, and with all that was happening — but trying to do it visually it was extremely difficult. It looked documentary. It was frustrating. But rather than go into a long story about that; the co-pilot who had climbed on to our ship had two bullet holes. One in the arm and one in the leg, and one we hadn't noticed, which was a third one, which was just under the armpit. And he died. The story came out in *Life* the following week. Some eighteen months later, the mother wrote to me. She said she had just seen another story which I did for the magazine. And she didn't really understand what I was trying to do or what I was trying to say — to be able to photograph death, to photograph the suffering. She said: "now, I understand, because of this last particular story which ran." And she said, "I want to thank you for whatever help you gave to my son, Jim, during the last moments of his life."

It was a very sad moment, a very touching moment, when our crew chief broke down — cried. Everybody was very tense, because everyone had suffered through it. And so often I wonder whether it is my right to capitalize, as I feel, so often, on the grief of others. But then I justify, in my own particular thoughts, by feeling that if I can contribute a little to the understanding of what others are going through, then there is a reason for doing it.

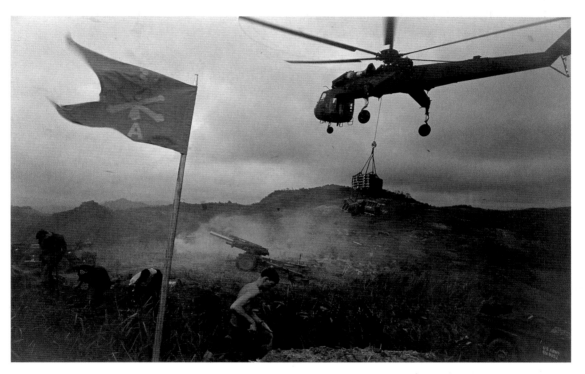

Ammunition Airlift into Besieged Khe Sahn, 1968
Dye transfer print, 1985
11¾ x 18 inches
Horace W. Goldsmith and Art Purchase Funds, 86.76

Eliot Porter
American, 1901–1990

Since taking his first photographs at the age of thirteen, Porter has become one of the most celebrated nature photographers of our time, and is credited with developing new methods of photographing wildlife. After pursuing a medical career, he turned his full attention to photography in 1939. In 1940, he began working in color in order to capture the subtleties of pigment in the plummage and leaves of his subjects. In 1979, Porter's images became the first color photographs to be shown at the Metropolitan Museum of Art; this text is taken from that exhibition book entitled *Intimate Landscapes:*

Though it is generally accepted that abstract art refers to those works inspired by the imagination of the artist rather than by objective reality, in photography, in which images are produced by the lens, this distinction is difficult to sustain. In the broadest sense of the term, an optical image is an abstraction from the natural world — a selected and isolated fragment of what stands before the camera. When the selected image is self-explanatory and does not imply more than what lies within its area it is usually referred to as abstract, that is, independent of its surroundings — a pattern of rock, for example, or lichens, or grasses. On the other hand, in the wider scenic view common in most landscape photography, the selected image implies a world outside the limits encompassed by the lens.

Photography of nature tends to be either centripetal or centrifugal. In the former, all elements of the picture converge toward a central point of interest to which the eye is repeatedly drawn. The centrifugal photograph is a more lively composition, like a sunburst, in which the eye is led to the corners and edges of the picture: the observer is thereby forced to consider what the photographer excluded in his selection.

I do not photograph for ulterior purposes. I photograph for the thing itself — for the photograph — without consideration of how it may be used. Some critics suggest that I make photographs primarily to promote conservation, but this allegation is far from the truth. Although my photographs may be used in this way, it is incidental to my original motive for making them which is first of all for personal aesthetic satisfaction.

Ultimately, to be successful as a work of art, a photograph must be both pleasing and convincing. It must not leave the viewer in doubt about the validity of its subject, whether representational or imaginary. Every part must contribute to the unity of the image from corner to corner — no discordant note should be permitted.

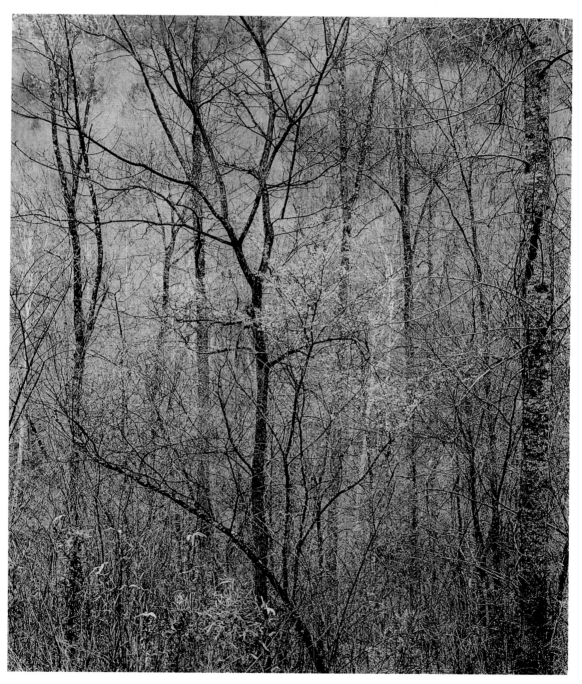

Redbud Trees, Red River Gorge, Kentucky, 1968
Dye transfer print
16 x 13½ inches
Horace W. Goldsmith Fund, 87.332

Jun Shiraoka
Japanese, 1944–

Shiraoka became interested in photography while working as a physics lecturer in Japan. In the 1970s, he went to New York for further photographic study, and in 1980 moved to Paris where he still lives today. While Shiraoka's photographs contain elements of both French and American sensibilities, his strongest influences are the art and Zen philosophy of Japan. His dark, ambiguous images force the viewer to look carefully in order to discern their contents. This statement comes from the catalogue of Shiraoka's first American solo exhibition in 1988. In it, Shiraoka comments on the personal nature of his images:

Ambiguity, uncertainty, clearness. Look, only look. To see, to see oneself, to be seen, what does it mean...?

I grew up in Japan, so my pictures may be Japanese in a way, even the pictures which I took outside of Japan. For instance, the weather in Japan is different from elsewhere. Perceptions are different in the West and in the East. The moon is a very important object in Japanese literature, but not in English literature. In painting, some Western painters paint the shadow, and some Oriental painters paint the mist. And the ways of painting perspective in two dimensions have been different in Japan and the West. But I want to see and look for a Universal image in the photograph, which not only means the same image in the West and in the East, but also that the image should be an eternal image which will not go out of fashion. I think that this is the reality which I am seeking.

I don't care about the composition of a picture. I just take a picture of a subject as I see it in front of me. I don't intend to explain a subject by its photograph, nor do I intend to give information about a subject by its photograph. Before I take a photograph, I never think what, how or why I am going to take a picture. I always carry a 35mm camera. And just when I feel something in what I am seeing in front of me, I try to capture an image of it on film. I want to capture on film the feeling which I feel, for example, when a light breeze blows on the beach at the end of summer. What does not exist for the senses, does not exist in the intellect....I shoot when I see myself in an image and the image in myself. To take a photograph to me is to objectify myself in the photograph. I take photographs to fill an emptiness in my life. I will never fill the emptiness. I will just go on taking pictures. These images might be my personal illusions, and they might be my personal obsessions.

Shimizu, Japan, summer 1969
Gelatin-silver print, 1987
9½ x 14¼ inches
Horace W. Goldsmith Fund, 86.391

Larry Clark
American, 1943–

After working for his family's portrait business in Oklahoma from 1956 to 1961, Clark relocated to New York where he works as a photographer, artist, and filmmaker. His 1971 book, *Tulsa,* chronicled the lives of his Oklahoma friends in a world of depravation dictated by drugs, sex, and guns. In these images Clark is not a moralizing observer, but rather an active participant. For Clark the pictures are a form of autobiography. The following interview was published in the May/June 1992 issue of *Flash Art:*

I've been a photographer since I was a teenager. My mother was a baby photographer, going door to door. I always had my Rolleiflex and strobe with me because I was working for my parents. I never thought about photography in other terms, as art or anything. But then I went to a commercial photography school which happened to be in an art school. So I was exposed to kids who were doing art and to a lot of the documentary photography from the old *Life* magazine of the fifties when they were doing those great photo essays. Eugene Smith had quit *Life* because they wouldn't give him enough time to do the assignments. He was always writing these diatribes about the truth, and how he wanted to tell the truth, the truth, the truth. It was a real rebel position. It was kind of like a teenager's position: why can't things be like they should be? Why can't I do what I want? I latched on to that philosophy. One day I snapped, hey, you know, I know a story that no one's ever told, never seen, and I've lived it. It's my own story and my friends' story. I would go back to Oklahoma and start photographing my friends. That's when it snapped — I wanted to be a storyteller, tell a story. Which I hate even to admit to now, because I hate photojournalism so badly.

In the beginning, I was just trying to make photographs. Someone would come in and I'd see a light and shadow and recognize things that were dramatic. First of all, I was trained as a portrait photographer. And you've got to make people look good or you don't get your

$10.95. Second, they're my friends and they're seeing the photographs as we go along. If you're coming back and showing them pictures where they don't look good, they're not going to want you to take their pictures anymore. Many photographers and photojournalists are great at grabbing the picture, being quick and focused and framing the composition, but they don't care what the people look like. I did. I could do all that plus get the person to look like I would like them to look, or they would like to look.

The shot of Billy on the bed with a gun, I always looked at that as like a baby picture. If you looked at some of the baby pictures my mother or I took, it could have been that pose. I didn't get it at first, but I knew it was great. It was a natural picture. With the white sheet in the background it could be a studio picture. I was able to get that quality when it was actually happening, that quality of looking set up. People often ask if I set these pictures up and then say, "No you couldn't have, but how did you get them to look like that?"

It [*Tulsa*] came out right after I finished it in 1971. The first section is 1963, the middle section is 1968, and then the last section is 1971. About half of the book is 1971. I went to Tulsa and did all those pictures in a matter of months. I knew every aspect of the life and knew what was missing from the book. I went back and was almost…waiting for those photographs to happen. I didn't know how they would happen but I knew I would be ready. It was a real hot period.

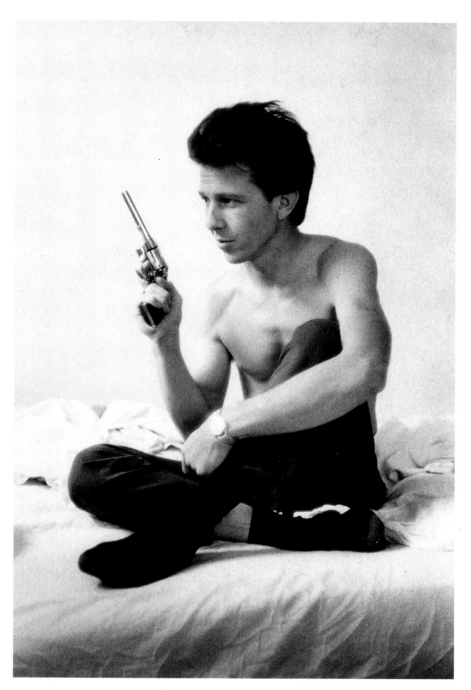

Billy Mann, Dead 1970, 1968
from *Tulsa,* 1971
Gelatin-silver print, 1980s
12½ x 8¼ inches
Gift of Robert W. Pleasant, 86.386.34

Robert Mapplethorpe
American, 1947–1989

Mapplethorpe studied drawing and painting before experimenting with a Polaroid camera in the early 1970s. Many of his first photographs, which are portraits of his artist and socialite friends, were taken in a style similar to that of Andy Warhol whose work he admired. His attention to the formal elements of composition and contrast is evident in his flower arrangements and nudes, as well as in his more confrontational depictions of eroticism and male sexuality. These statements, from a 1987 interview, reveal Mapplethorpe's concerns with approach and style:

I think the pictures I take dealing with sexuality are probably the most potent of pictures that I have ever taken. They are the pictures that people remember more because they are unique. They also stand out from the rest because they somehow reflect the impact of an inner feeling of sexuality. They are more intense, though I don't think they're any more important than my other pictures. Sometimes, though, they are the only ones people remember....

The way I approach art in general — I take it as it is. I don't come to it with prejudice. It's like when I photograph celebrities. I often don't know who these people are until the moment I meet them. I don't have this pedestal notion that I think a lot of photographers have when they photograph celebrities. They go in thinking how important it is that they are photographing so and so. I often don't know who these people are. It's not that important to me and I think it is a great advantage to approach things that way. I think it's given me access to a lot of people because I'm not in awe of anybody and I never have been. I'm just not the kind of person who has heroes. I never had heroes....

Remember I knew nothing about the history of photography at that point [when he started photographing]. It's interesting because my style was developed even before I knew who Steichen or Stieglitz was. It was like, I had a way of seeing and that was it. That's not to say that over the years having studied has not helped me define what my photography is about. I think that it was a great advantage to go into photography not knowing much about it. Not thinking. I think one of the problems with many photographers today is that they never see for themselves, but just like everybody else....

Photographers are usually terrible about editing. But it's part of being an artist. It's one of the objections I have to these young painters. Every doodle they do they put out there. I think I could do your portrait and maybe choose the two best pictures and convince you in the end that they are the right ones. They may not be the prettiest of pictures, but there is a certain kind of thing that comes out of them....

I believe in certain kinds of magic. Sort of an abstract energy concept. I think there's a magic that can invest in photography sessions. It's not about the fact that I know more about photography, but that I can muster up this certain kind of thing that makes a great picture. Even when my assistants do virtually all the work the picture still has me in it.

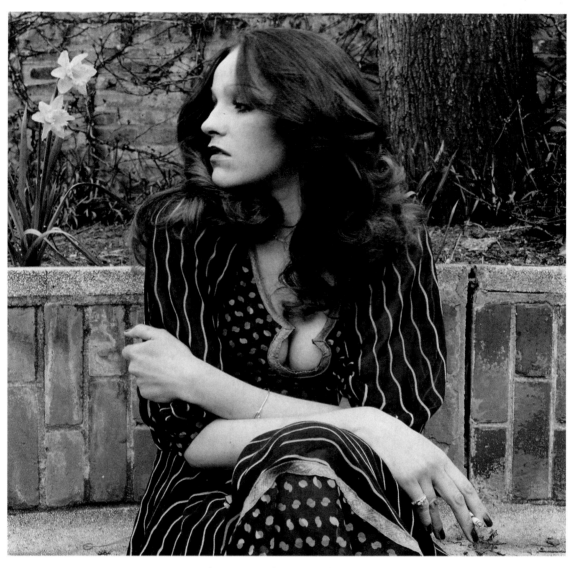

Lady Rose Lambton, London, 1976
Gelatin-silver print
13⅞ x 13⅞ inches
Gift of the artist, 78.418b

Joel Sternfeld
American, 1944–

Using an eight-by-ten-inch view camera, Sternfeld photographs the meeting places of humans and nature, capturing the effects of technology on the landscape, and the ways in which landscape has influenced the advance of civilization. Often his images are filled with irony and surprise as he explores aspects of ordinary life. In this exploration Sternfeld also looked back to the photographic documents of 1930s America taken by artists such as Walker Evans. Sternfeld's photographs allow us to see the beauty of our landscape while acknowledging the price we pay for technology. The following statement was selected by the artist for this book:

In the spring of 1978 I received a Guggenheim Fellowship to continue a series of street photographs. But the award and the possibilities it created encouraged a change in my work.

All at once it seemed as if the entire continent, every region, every season, and every photographic means were within reach.

In time the thematic structure of a new body of work emerged.

Although I was only thirty-three years old, I had the sense of having been born in one era and surviving to another. The photographs which I made represent the efforts of someone who grew up with a vision of classical regional America and the order it seemed to contain, to find beauty and harmony in an increasingly uniform, technological and disturbing America.

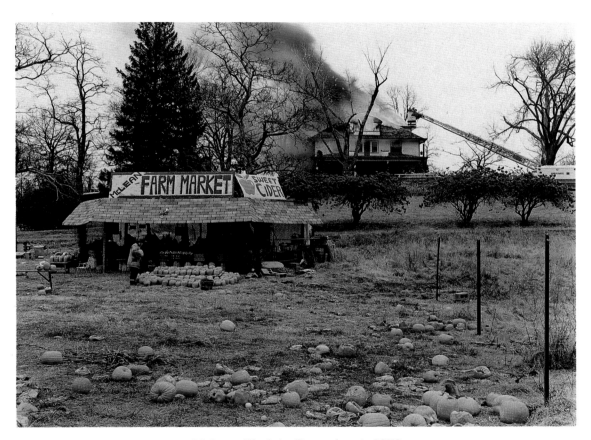

McLean, Virginia, December 4, 1978
Dye transfer print
15 x 19½ inches
Horace W. Goldsmith Fund, 84.270

George Tice
American, 1938–

A self-taught photographer, Tice has been working in photography since he was fourteen years old. A master technician, he frequently uses the eight-by-ten-inch view camera and is largely responsible for the resurgence of interest in the platinum printing process. Tice works with the extended photo-essay and has published more than a dozen books of his photographs, including *Fields of Peace: A Pennsylvania German Album* (1970), *Paterson* (1972), *Urban Landscapes: A New Jersey Portrait* (1975), and *Hometowns: An American Pilgrimage* (1988). Tice submitted this statement about the creation *From the Chrysler Building:*

My photograph *From the Chrysler Building* resulted from a commission I received from the Association for a Better New York. It was their purpose to create and publish a series of posters on the theme — "New York, New York." I was free to present my own concept of the city. Because of the official nature of my commission, I thought I might gain access to vantage points that I could not on my own.

I started thinking about photographing the city from a skyscraper and that idea brought to mind a 1934 photograph by Oscar Grauber of Margaret Bourke-White perched atop a gargoyle jutting off the 61st floor of the Chrysler Building. She is depicted aiming her Graflex camera at something higher.

I informed the Association of my idea to photograph from the Chrysler Building, and they paved the way and obtained the permission needed. They also took out an insurance policy on my life. I remember photographing with the policy sticking out my back pocket.

To approach the gargoyles I had to climb out an office window with my view camera to a walkway. Once up there, I realized I had a larger choice of eagles than I had thought. Instead of the four I anticipated, there were eight. Juxtaposed against the city, each provided different views. I passed several hours of a sunny June day studying the various compositions presented by each gargoyle as the light changed. Finally, I selected a view looking past the Lincoln building toward New Jersey, whereby I could include the people and traffic on the streets below.

After developing my film, I was pleased with the composition, but I did not like the harsh effects produced by direct sunlight. A week later, on a grey day, I returned to the Chrysler Building's 61st floor and took it again.

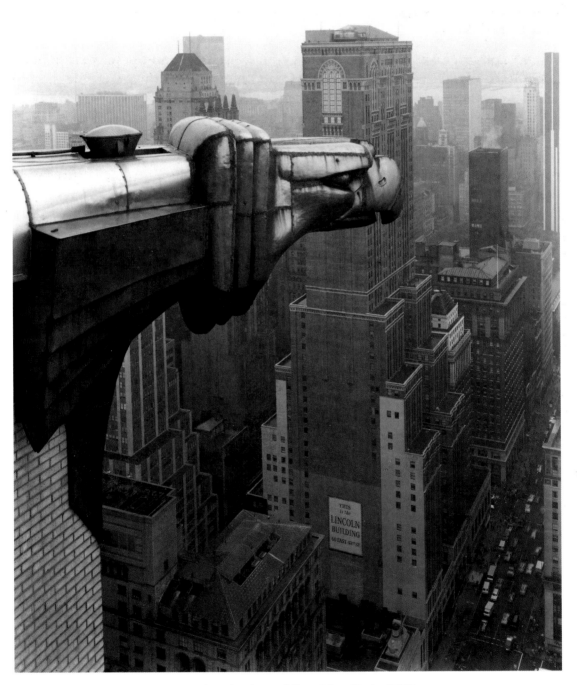

From the Chrysler Building, New York, 1978
Gelatin-silver print
19⅜ x 15⅜ inches
Purchase, 86.203

John Pfahl
American, 1939–

Pfahl's photographic projects combine the conceptual and the pictorial in an effort to understand the effects of human intervention on nature; this is especially true of *Altered Landscapes,* his first body of substantial work made in the mid-1970s. His series entitled *Picture Windows,* taken between 1978 and 1981, continues Pfahl's exploration of the nature of perception by creating pictures within pictures, using views of "picture window" themes seen through the frames that surround them. Pfahl's work — including later series such as *Power Places* and *Smoke* — offers provocative views of contemporary landscape which challenge traditional portrayals. Pfahl's statement for this book addresses his technique of creating frames from existing structures:

While making my *Picture Window* photographs, I came to think that every room was like a gigantic camera forever pointed at the same view. In the dictionary, of course, the word camera in Latin means chamber or room.

I searched the country for these cameras and their views: the more unusual or picturesque, the better. It was hard to tell from the outside what could be seen from the inside, so I was usually surprised when I discovered a scene in its new context.

Strangers with puzzled looks were amazingly cooperative in letting me into their rooms with my photographic gear. They let me take down the curtains, wash the windows, and rearrange the furniture. Often, too, they expressed their desire to share their view with others, as if it were a nondepletable treasure.

I liked the idea that my photographic vantage points were not solely determined by myself. They were predetermined by others and patiently waited for me to discover them.

This scene was photographed along a boating canal in Coral Gables, Florida. The glass louvers reflect my wife in a bikini sunbathing on the balcony, superimposing a second, more fragmented image on the sunny view.

1390 S. Dixie Highway, Coral Gables, Florida, 1979
Chromogenic print
15⅞ x 19⅞ inches
Purchase, 81.25

Sheila Metzner
American, 1939–

Metzner worked as an art director for a major advertising firm before devoting herself full time to photography in 1968. The pictorializing effects of her early black and white still lifes and nudes are evident in her later color photographs, which are printed using the turn-of-the-century Fresson process. Seeking the perfection of form through color and texture, Metzner's soft focus photographs have been described as blending a timeless intimacy with modern elegance. The following introspective statement, selected by the artist, was printed in *The International Annual of Photography:*

Photography in its most basic form is magic. A figure, an object is before the box with a hole in it. A sensitized film, absorbs the light passing through the aperture in the box. In the box is darkness. It is developed in darkness. The image is fixed on the film. The image is in reverse of reality. Then, either by contact print or enlargement, the image, passed through light again is transferred onto another sensitized paper. Again, in darkness. The paper is set in a chemical bath which causes it to appear slowly in positive form. What we saw in nature is now two dimensional and can be lifted, fixed, washed, dried and held in my hands. I can carry this portrait, landscape, still life from room to room, set it on a table and look at it whenever I wish to. This image, caught in my trap, my box of darkness can live. It is eternal, immortal. The child in the image will not age as the living child will. This is magic.

What then, having this power, to stop time, as a God does, to create immortality, to trap a moment in life, what, is my responsibility? What am I looking for? What do I want to preserve, worship, retain, present as my legacy to the world at large, for myself, my family, my friends?

All of the above words when read, silently, or aloud create in me images, which reflect, which mirror, my inner life. My deepest, darkest, brightest thoughts and feelings. They inspire my intellect, what is finer in me. They inspire a search, a journey, a wish for contact with the divine. They inspire intimate contact with my surroundings. I am magnetized, pulled into contact with a face, a body, a body in a certain light, toward a relationship which is true.

The energy for this work must be fed. The impressions themselves are my food. I am stronger when I am conscious of myself in relation to what I am photographing. The journey, the work, the process includes me. The work, the photograph is a reflection, a mirror of my being.

Therefore, my transformation, my well being is essential to the life of the photograph. So photography is a reciprocal relationship. We nourish one another....All at once the image reveals itself to me. It is my gift. A gift for the effort I am making to go into the unknown.

Into the question. Into not knowing why I am there, what I am doing. I push the button. Standing or kneeling, or sitting, terrified or laughing, serious or thrilled. I pray that the image was caught, captured in the darkness of the little black box. I am the genie, holding the bottle. Inside swirling is the storm, or the face, or the flower, or the ice, or the stone.

The photograph is something, in its highest form that I am given for my effort. It is not something that I take. And then after I bring it back, develop it, print it, look at it, experience it again, I submit my experience to life. I give it back to the world, it came from. Light into darkness. Darkness into Light.

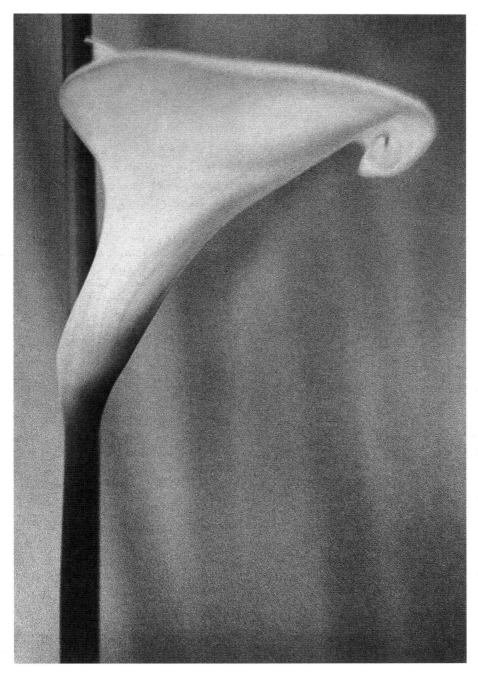

Calla Lily, 1980
Fresson print
19⅛ x 12⅞ inches
Purchase, 81.22

Chuck Close
American, 1940–

Dissatisfied with his work after completing graduate studies at Yale University in the late 1960s, Close began using photographs as foundations for his paintings. Using himself and his friends as subjects, Close made a series of large-scale portraits based on photographic guides; the over life-sized heads are tightly cropped and display almost hyperreal detail. He later worked with acrylic and airbrush to simulate the process of color separation through which a printing press reproduces color photographs. In this interview, Close explains that becoming a photographer was not something he had originally intended:

The main reason I started making photographs was that I knew that I wanted to do very sustained paintings. I wanted to work for literally months on a piece and I didn't want to have the model around, and I didn't want the condition to keep changing, that is, you know the model gains weight and loses weight; their hair grows long or becomes bald; they're asleep, or they're awake, and the painting becomes a kind of the average of all of those. You keep responding to them differently because they're there. So I wanted something that was a frozen moment in time that would have some of the urgency of a split second even though I was going to spend in some cases up to twelve to fourteen months working on one picture. I wanted the paintings to look like they just happened. It didn't look labored, or I didn't want people to think about, "Oh my God, look at all that work this guy did." So I thought that this was some way to keep a kind of clone-like cross section of time, a quick moment, while I worked in a much more novelistic time frame, an incremental way, very much the way a writer pieces together a work....

At first I never thought of my photographs as end products, at least I didn't consider myself a photographer because the thing I was making was a painting; therefore, while the photographs were an essential ingredient in the process, they had a souvenir or by-product status: something that was necessary without which the final product, the painting could not be made. But, they had no particular object status for me other than as souvenirs. I often gave them away to friends. I remember trading one for a couple of kitchen chairs. So I didn't think of myself as a photographer. I have very narrow expertise in photography. That is, I learned to do what it is that I need to do, and I know very little about other aspects of the photographic process. I always did my own dark room work. In every black and white print I would spend long hours in the dark room dodging and burning and building into the photograph those things that I wanted to work from....

Now at a certain point, around the mid-70s, I was invited to work in Polaroid. Prior to working with Polaroid, if I took a photograph I had no idea what I had until I developed the film. So I tended to take the same photograph over and over, just bracket the shot just to make sure I had the right exposure. The minute I started working with Polaroid I realized that as soon as I got a print that I thought I wanted to work from, there was no reason to make more versions. I began to take photographs that I had really no intention of making a painting from. So I reluctantly began to accept the fact that if I'm making photographs in no life other than that of a photograph, then golly, I must be a photographer. So I sort of backed into it. Thinking about myself as a photographer — it's still something I'm not totally comfortable with.

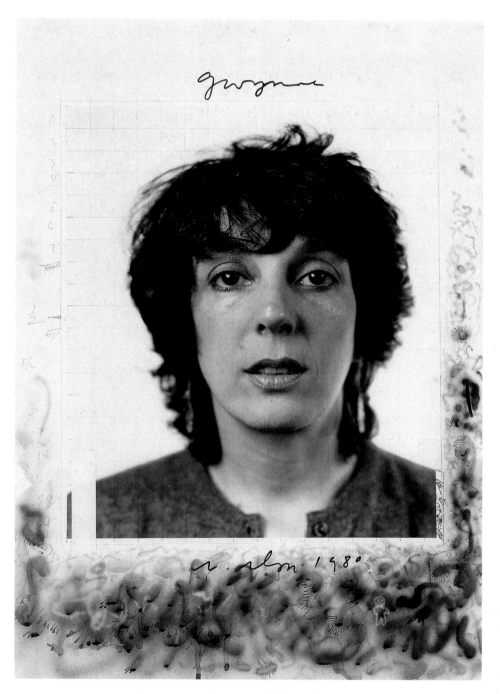

Gwynne, 1980
Gelatin-silver print, ink, and tape
30 x 20 inches
Purchase and National Endowment for the Arts, 89.100

William Christenberry
American, 1936–

A sculptor and painter, Christenberry was drawn to photography in 1959 when he stumbled upon the photographs of Walker Evans in James Agee's *Let Us Now Praise Famous Men*. The subjects of Evans's images of the South were familiar to the native Alabaman, and inspired Christenberry to take his own photographs of this region, primarily in Hale County where he was raised. He is particularly attracted to the simple forms of vernacular architecture and their relationship with the landscape they inhabit. Christenberry, who lives and teaches in Washington, D.C., explains the importance of photography to his artistic work:

When I first began making photographs in the late 1950s, I used a Brownie camera. I had been making these photographs over the years just for myself, and they were color references for my paintings of the Alabama landscape. These small photographs are probably among the most natural things I've done, for I did not think of them as art.

In 1977 I started using an eight-by-ten-inch view camera and since that time have concentrated my efforts on it.

Photography has always been a part of my artistic activity, which also involves painting and sculpture. I use these media to express the many concerns and feelings in my life and about my background. It is the relationship of all these means of expression and their totality that best exemplify my work.

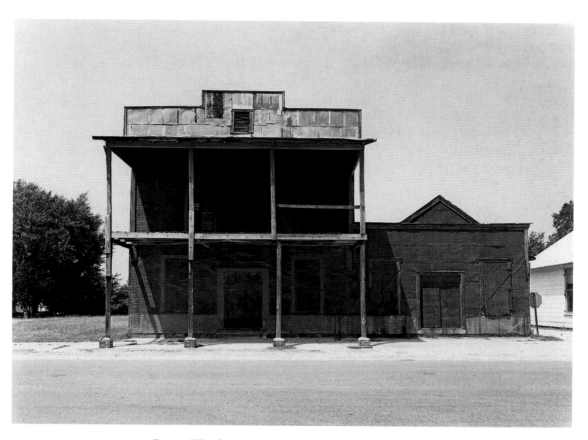

Cotton Warehouse, Newburn, Alabama, 1980–1981
Dye transfer print
17 x 21¾ inches
Purchase, 82.19

Robert Glenn Ketchum
American, 1947–

With his photographs, environmental activist Ketchum captures images of nature's beauty with respect and compassion while at the same time informing the public of the danger in our assault on her resources. He has also published several books, including *The Hudson River and the Highlands* (1982). His book *The Tongass: Alaska's Vanishing Rain Forest* (1987), led to a Congressional vote of protection for that area. In the following, Ketchum describes his photographic series *Order from Chaos:*

Begun in the early '70s and published as two portfolios in 1983, the eighteen color prints in this series were a formal exercise on my part to explore the rectangle of the print as a whole. I wanted to shift the hierarchy of the photograph from the subject depicted, to the print itself. I also wanted to explore identifiable landscapes in an abstract manner, without resorting to manipulation, or reducing the subject to just a partial detail of the whole.

My intent was to reject the intentionally descriptive viewpoint expressed in much of the historical tradition of landscape photography, while still retaining a perspective the viewer would believe to be "as the eyes would see it." Using a four-by-five-inch view camera to record every minute detail, I found the complex diversity and unbelievable seasonal colors of the eastern deciduous forests best suited to my purpose. In complicated, layered compositions, I confused obvious orientation by camera angle, and destroyed spatial perception through the use of line, color, and form in uncountable layers. The great depth-of-field available to view cameras allowed me to maintain overall sharpness in extremely complex circumstances, making every individual plant, bush and tree equally important to the overall pattern of the composition. This visual democracy only furthered the sense within the print of the connectedness of all the living things I had photographed.

Constructed very precisely in camera, these images were also printed full-frame, and the large scale of the prints was purposeful, to further enhance the viewer's experience of being engulfed by the hyperactive pattern forms and intense detail.

I also chose to reject the traditional site-specific titles commonly associated with landscape photography at the time. I have always felt that such titles rob the subject of its metaphorical potential, and surely would have impaired the very abstract sense my pictures were trying to evoke. I borrowed from the writings about Jackson Pollock when I called the collective series, *Order from Chaos.* When asked facetiously how he knew when his paintings were finished, he replied that a certain rhythm — an order — arose from the chaos, signaling to him the painting's conclusion. I felt similarly about the process I used to extract my compositions from the skein of the forest.

Individual picture titles were another story entirely. They were all whimsical, and often referred to lines or titles from literature I was reading, or songs I was listening to while working on the prints. Each title has a reference, but the references are obscure, and I do not expect viewers to necessarily understand exactly what those titles mean without asking. In the case of the image selected here, *And Gravity Lets You Down,* is a line from a song by a band, Talking Heads. Because the viewer's perspective in my photograph is somewhat elevated — above the tree and looking down through it to the ground — the idea that "gravity lets you down" seemed to fit. This isn't romanticism, it is humor.

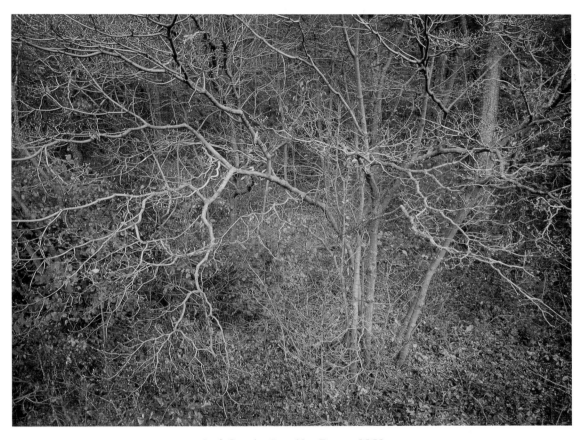

And Gravity Lets You Down, 1981
Dye bleach print
30 x 38¼ inches
Horace W. Goldsmith Fund, 87.113

Zeke Berman
American, 1951–

Originally trained as a sculptor, Berman began to experiment with photography in the late 1970s employing his own constructions as subject matter. Berman's work challenges the viewer's perception through optical illusion and paradox: His images suggest dimensions, but exist on a planar level. Committed to conceptual modes of art-making, the photographer transforms the physicality of his subject matter into abstract ideas. The following statements are taken from written text and a conversation with Berman:

In this image I used a device of laying out material in a space in the studio that when seen from the one point of view of the camera read back as somewhat maybe short of two-dimensional. It seems to be hovering on the picture plane, which is actually laid out in three-dimensional space just the way the table is. It's a device that at some point became exhausted. This is the last picture I associate as being at the end of one body of work and the beginning of something else. It's a sort of a setting sun kind of picture....

I originally made sculpture but became attracted to placing a camera between myself and what I make. This results in an isolation and distancing that changes a physical construction into an optical one.

Test the characteristics of one medium against another. Test the characteristics of one system of knowledge against another.

For me, the studio was first a safe haven, then a cave, then a laboratory.

Since 1983, I've been enrolled in the school of Jasper Johns.

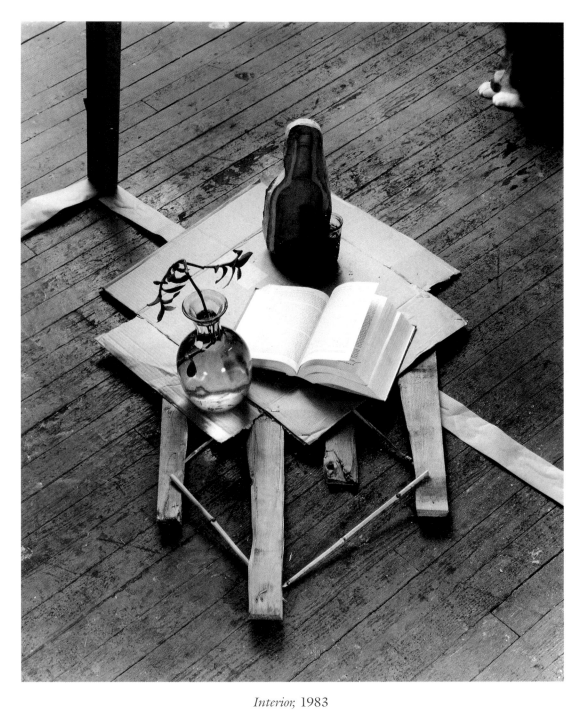

Interior, 1983
Gelatin-silver print
19 x 15 inches
Horace W. Goldsmith and Art Purchase Funds, 85.151

Mary Ellen Mark
American, 1940–

A leading documentary photographer, Mark has traveled all over the world on assignments for *National Geographic, Life,* and the *New York Sunday Times Magazine.* She frequently chooses people on the fringes of society as her subjects, evoking strong emotional reaction from the viewer through the sensitivity and compassion of her approach. Mark's projects have resulted in the publication of several books, including *Falkland Road* (1981), which portrays the existence of prostitutes in Bombay, and *Streetwise* (1988), an exploration of life for young runaways on the streets of Seattle. Mark prepared the following statement for this book:

This is a portrait of Erin Blackwell. Her street name is Tiny. In 1983 I traveled to Seattle to do a story about runaway kids for *Life* magazine. Tiny was then a thirteen-year-old street child. The first time I saw her was in a parking lot. She was wearing a tight sweater, tight jeans, high heels and lots of make-up. She looked like a little girl playing "dress up." I approached her, introduced myself and asked if I could spend time with her. I spent the remaining weeks photographing her.

Several months later I returned to Seattle with my husband Martin Bell who made the documentary film *Streetwise*. Tiny was the main character in that film. This photograph was taken on October 31, 1983. I remember the date because it was Halloween and the last day of shooting on the documentary film. Tiny was on her way to a party at a social center for street kids. She put her costume together out of old secondhand "give away" clothes. She told me that she wanted to dress like a French prostitute. She was, as always, the little girl playing "dress up."

Since 1983 I have kept in constant contact with her. She is now 25 years old and has four children. All of them have different fathers. She has seen good times and very bad times. Life has taken its toll on her physically, but she still has that amazing candid vulnerability that I am drawn to. I hope to continue to know her and photograph her throughout my life.

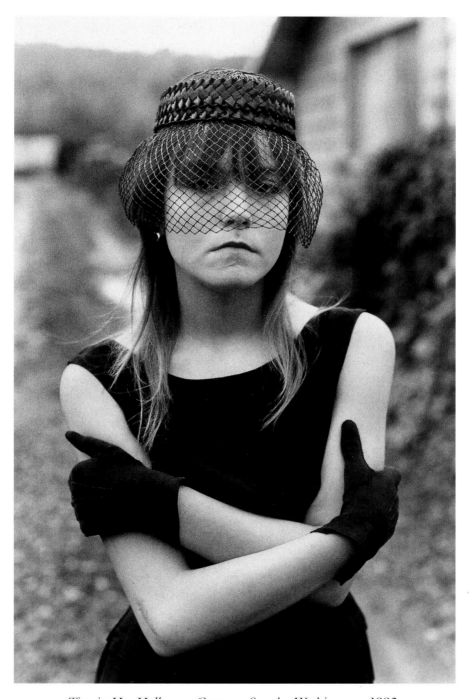

Tiny in Her Halloween Costume, Seattle, Washington, 1983
Gelatin-silver print, 1995
13¼ x 8¾ inches
Gift of Suzanne and Jack Jacobson, 95.16

Nancy Burson (with Richard Carling and David Kramlich)
American, 1948–

Since 1982, Burson has collaborated with computer scientists David Kramlich and Richard Carling in designing unique software that she uses to create composite portraits. Modern technology enables her to scan images into the computer, stack the faces on top of one another, and then manipulate them to produce portraits that are often politically motivated, and always provocative. An aging program developed by Burson in the late 1970s has been used by the Federal Bureau of Investigation to "age" missing persons and to construct suspect sketches. Burson, who lives and works in New York, provided the following brief but insightful commentary for this book:

All of my early images were really visual experiments to me. They were an attempt to answer unasked questions like, what happens if you put images of six men and six women together, or if we combined a monkey's image with a human, would the result approximate an image of early man?

Three Major Races was inspired by Ursula LeGuin's *Lathe of Heaven*, in which all the races meld together to form one grey race. It is a photo of no one and everyone.

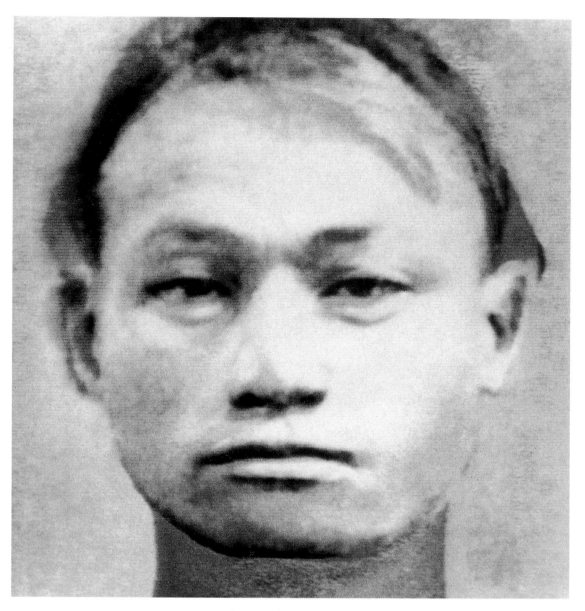

Three Major Races, 1982
An Oriental, a Caucasian, and a Black
Gelatin-silver digital print, 1995
9 x 8¼ inches
Gift of Decipher, Inc., 95.5

Michael Brodsky
American, 1953–

Working exclusively with computerized imagery since 1983, Michael Brodsky has become a pioneer in the exploration of electronic media. His early work consisted of gelatin-silver photographs made by printing multiple negatives with transparency overlays. In addressing political and social themes, he has created works combining images and text, produced *Media Probes* — a series of graphically-altered television images — developed a color series titled *Techno Bliss/Techno Fears.* Brodsky reflects on his work in the following:

Instead of merely copying pictures off of the TV screen, I always wanted to create images directly from the very components of the broadcast airwaves themselves. This became possible in the 1980s with the availability of low cost personal computers (I had attended Homestead High School in the 1970s with the founders of Apple Computer, Steve Jobs and Steve Wozniak) coupled to the development of digital video imaging which allowed video to be converted directly to a digital compatible format which could be processed with a computer. This technology was a direct outgrowth of the space research of the '60s and '70s which kept me mesmerized in my youth. Just as a photographer can walk down "streets" and photograph what he or she sees, I could finally, with the aid of a computer, television-tuner, cable, and a satellite dish, wander through the image world with the flick of my remote.

Television amongst all of its hype exists as a vast cultural wasteland, which while often visited, is rarely explored in depth. With a television remote control in hand, I seek to document this "virtual landscape," which in our society has become seemingly more real than the physical world around us.

Television images appear to move, but they seldom move us. Mostly we sit passively and watch for something to happen. Much of what we know comes from television, yet most people fail to understand the world of broadcast media. Few people see the choreography of time and space within their television set. Fewer people yet, see the edits and dissolves of their lives reflected by this collective transmitted experience.

My digital images are captured from the television broadcast airwaves and reconfigured with the computer, much in the same way that the mind captures, processes, and reconstructs our own perceptions of reality. The darkness, scene edits, and the pixel deconstruction speak to the synaptic gaps that feed nerve impulses to our brain.

I am trying to make my images move as if in a world of electrostatic interference and transmitted energy. In doing so, I seek to explore the frequencies of the broadcast wavelength, as well as the gaps between human impression, memory, delusion, and recollection.

There seems to exist in my images a recursive paradox that runs between television broadcast programming and the programming of the early childhood experiences which shape our current lives. Technology and psychology, if you like, are a very dangerous mix. Having grown up in front of a glowing television vacuum tube with a frozen TV dinner on my lap, I can't help but read between the scanning lines that form the television image.

Television always seems to be selling both product and dreams, but in reality what is being sold, is a bill of goods. "TV dreams" clash with the reality and lies of single direction communication. Fragments and distortions, of half truths and promises, seem to be the indelible image that is etched in my psyche and on my digital canvas. This is the legacy to all of those that grew up addicted to our television culture.

Media Probes SF, 1985
Gelatin-silver digital print
4¾ x 7¼ inches
Horace W. Goldsmith Fund, 86.322

Len Jenshel
American, 1949–

Considered one of the leading photographers of the American landscape, Jenshel creates haunting, surreal images of backroads and empty spaces. His depiction of color is almost ethereal, and plays on the viewer's emotions as does the often striking quality of light. Like Joel Sternfeld and Robert Glenn Ketchum, Jenshel frequently captures scenes juxtaposing the beauty of nature with the effects of encroaching civilization. In the following statement, he describes his experiences while working on the set of David Byrne's *True Stories:*

I arrived in Dallas, Texas, in October of 1985 to participate in one of the strangest and most interesting commissions I had ever received. David Byrne, the avant-garde artist and lead singer of the Talking Heads musical group, was making his first Hollywood movie.

David had commissioned William Eggleston and myself to come down for ten days of filming to make pictures about anything we wanted — on the set, off the set — no restrictions. The resulting bodies of work would be published in a book that might be about the making of the movie, and than again, might not — no one really knew yet.

Loosely described, the movie, *True Stories,* was a tongue in cheek comedy with characters inspired by the tabloids. It would be a great portrait of middle America suburbia, among other things — but for me, it was about the blurring of real and unreal.

Perhaps my favorite line in the film is recited by the "lazy woman," who has not been out of bed for years. She sits in bed with the remote control channel surfing, and blurting out repetitiously, "commercial or video, commercial or video." With this as inspiration, I decided to split my time on the movie set and in the "real" world. As I traveled and photographed around suburban Dallas, I could hear myself saying, "commercial or video;" "Hollywood or Dallas;" "real or unreal." Consciously and playfully, I sought to blur that very fine line between worlds — for isn't that what photography does so well?

The photograph reproduced here, *Dallas, Texas* was made on the movie set — then again, maybe it was not.

Dallas, Texas, 1985
Chromogenic print
12¾ x 19 inches
Purchase, 87.328

Sally Mann
American, 1952–

Mann lives and works in her hometown of Lexington, Virginia, creating photographs that portray the beauty and individuality of her three children. Her images convey a sense of their daily struggles and reactions to ordinary and extraordinary events, as well as chronicle the changes in mind and body as her children grow older. She has taught and exhibited nationally, as well as published several books, including *Immediate Family* (1992) and *Still Time* (1994), which reproduces her color work and platinum prints. Mann reflects on her art in the following statement:

I photograph my children growing up in the same town I did. Many of the pictures are intimate, some are fictions and some are fantastic but most are of ordinary things every mother has seen; a wet bed, bloody nose, candy cigarettes. They dress up, they pout and posture, they paint their bodies, they dive like otters in the dark river.

They have been involved in the creative process since infancy. At times, it is difficult to say exactly who makes the pictures. Some are gifts to me from my children: gifts that come in a moment so fleeting as to resemble the touch of an angel's wing. I pray for that angel to come to us when I set the camera up, knowing that there is not one good picture in five hot acres. We put ourselves into a state of grace we hope is deserving of reward and it is a state of grace with the Angel of Chance.

When the good pictures come, we hope they tell truths, but truths "told slant," just as Emily Dickinson commanded. We are spinning a story of what it is to grow up. It is a complicated story and sometimes we try to take on the grand themes: anger, love, death, sensuality and beauty. But we tell it all without fear and without shame.

Memory is the primary instrument, the inexhaustible nutrient source; these photographs open doors into the past but they also allow a look into the future. In Beckett's *Endgame,* Hamm tells a story about visiting a madman in his cell. Hamm dragged him to the window

and exhorted: "Look! There! All that rising corn! And there! Look! The sails of the herring fleet! All that loveliness!"

But the madman turned away. All he'd seen was ashes.

There's the paradox; we see the beauty and we see the dark side of things; the cornfields, the full sails, but the ashes, as well. The Japanese have a word for this dual perception; *mono no aware.* It means something like "beauty tinged with sadness." How is it that we must hold what we love tight to us, against our very bones, knowing we must also, when the time comes, let it go?

For me, those pointed lessons of impermanence are softened by the unchanging scape of my life, the durable realities. This conflict produces an odd kind of vitality, just as the madman's despair reveals a beguiling discovery. I find contained within the vertiginous deceit of time its vexing opportunities and sweet human persistence.

In this confluence of past and future, reality and symbol, are Emmett, Jessie and Virginia. Their strength and confidence, there to be seen in their eyes, is compelling; nothing is so seductive as a gift casually possessed. They are substantial; their green present is irreducibly complex. The withering perspective of the past, the predictable treacheries of the future; for this moment, those familiar complications of time all play harmlessly around them as dancing shadows beneath the great oak.

Jessie and the Deer, 1985
Gelatin-silver print
19¾ x 23⅝ inches
Horace W. Goldsmith Fund, 87.329

Sal Lopes
American, 1943–

On the day of its dedication in 1982, Lopes began documenting visitors to the Vietnam Veterans Memorial in Washington, D.C. Without sensationalism, he captured the effects of the Wall's power on those who had lost loved ones in the Vietnam War. Many of these photographs were published in the 1987 book *The Wall: Images and Offerings from the Vietnam Veterans War Memorial*. His 1994 monograph, *Living With AIDS,* presents a moving photographic journal of those affected by AIDS. Lopes, who works in Boston, prepared the following comments regarding the bittersweet nature of his work for this book:

This is a photograph of Keefer, one of the many reluctant warriors I photographed at the Vietnam Veterans Memorial in Washington. The memorial is a place of national healing honoring those who died and more importantly, those who have survived. It has become a shrine where people leave offerings, and communicate with the dead. It is easy to forget that no one is buried there. Over time, I have photographed people sharing grief, guilt, love, and celebration.

Much of my work during the past ten years has dealt with loss and memory. Using the portrait, I photograph people of integrity, courage and dignity — pictures of survivors who show pride, pain, and love. I can't be the detached photographer the profession seems to demand. I gain the trust of the people I photograph by allowing myself to feel their pain and by working close with short lenses.

I photograph issues that concern and move me. I am successful when my work takes on a life of its own, when it forces people to confront their emotions, when it allows a viewer to make their own judgements, when it shows the true cost of abstractions such as war.

The Vietnam Veterans Memorial, November 1986
Dye bleach print
8½ x 12¾ inches
Horace W. Goldsmith Fund, 87.359

Burk Uzzle
American, 1938–

Self-taught, Uzzle began his career in photography on the staff of the *Raleigh News and Observer*, and in 1962, worked as a contract photographer for *Life* magazine. He joined Magnum Photos in 1967, and was president from 1969 to 1970. His 1984 book *All American* was a humorous, straightforward look at America. Uzzle's most recent work employs multiple exposures made in the camera to express more complex issues than can be revealed in a straight documentary photograph. This statement was published in a 1992 exhibition catalogue entitled *A Progress Report on Civilization*:

After all those years of wandering around as a street photographer and as a journalist, I decided that this world is such a curious, screwed-up place so full of contradictions…that I couldn't look at it anymore in the raw form without trying to find someway of balancing it in a more philosophical context — less in a repertorial manner and more in an artistic one. And I like to think of these pictures as visual music — the theme of which has more to do with philosophy then sociology. You just have to take an attitude about life: I'm going to get through this. It may be difficult, but in the end it can balance and work. So that's why these pictures started coming about this way.

This [*My Precious*] started out as a photograph of American symbols: jeans, the Statue of Liberty, and the violence which so characterizes our country now and the hope of children too, to transcend it all. So you have the affirmation of a father holding a happy child and his brother and what the country's always believed in which is liberty and the violence of the gun which is both — I'm sorry to say — probably a necessary attribute of our culture for survival for an awful lot of people.

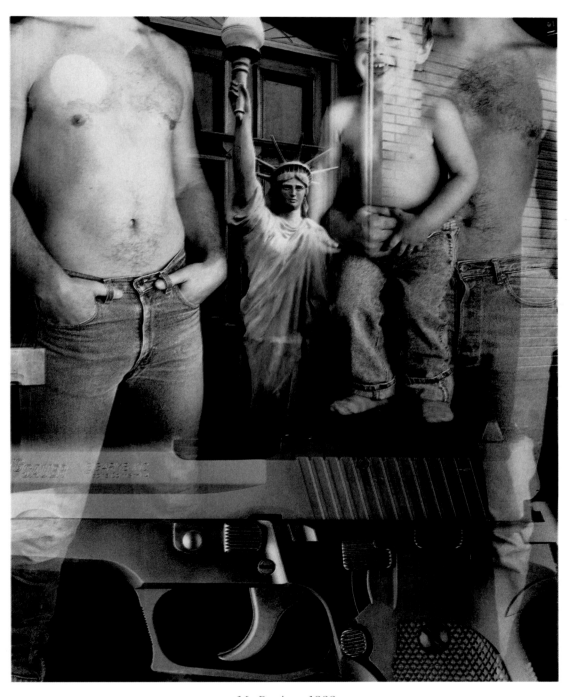

My Precious, 1988
Gelatin-silver print
23¼ x 18¼ inches
Gift of the Artist, 92.23.2

Robin Schwartz
American, 1957–

Schwartz began her series of primate portraits in 1987. With this project she desired to capture the individual personalities of her subjects; however, by photographing the animals in their adopted homes, she demonstrated their instinctual need to take on the characteristics of their human owners. A selection of these images published in *Like Us: Primate Portraits,* illustrates the results of these relationships. This text combines the introductions to her books *Like Us* (1993) and *Dog Watching* (1995):

Animals are the passion and obsession that fuel my imagination. The boundary line separating people and animals has always been blurred for me, and perhaps because of that, I try to develop a dialogue with my subjects, whatever their species.

I always attempt to make friends with the animals so that I will be remembered on the next visit. Our interaction was essential, for without the primates' consciousness of me I would not have been able to capture the intensity of eye contact. When I began this project, my goal was to reveal the primates' personalities. Then, thinking of fantasy images from children's books, I tried to direct the primates, but mostly I photographed by instinct, having the flash freeze the image of my rapidly moving subjects. I usually photographed within three feet, with a 35mm lens, never through bars or Plexiglas cages.

Although I was able to photograph many species, what you see is a fictional world of primates. I sought photographs that do not represent the everyday world of monkeys and apes in captivity. It is not my intention to encourage primate pet ownership, but to show a side of its' existence, to present each primate as a unique individual, and to share my photographic fantasies.

I believe that animals, kept as pets, offer us a unique glimpse into the heart of the human culture that surround them. How a society treats its' animals is a reflection of its' humanity. The relationship of pet and owner cuts across economic classes, and reveals much about a cultures' compassion. My connection with animals has guided my work and life. I have found great humanity, love, respect, adventure, and comfort in their company.

Minnie, 1989
Gelatin-silver print
12⅛ x 18⅛ inches
Gift of the Artist, 93.29

Patrick Nagatani
American, 1945–

Andrée Tracey
American, 1948–

For a six-year period in the 1980s, Nagatani and Tracey collaborated on constructing elaborate, life-sized sets incorporating photographic cutouts, painted backdrops, complicated props, and live figures. Their large-format Polaroids of these scenes are characterized by glowing oranges, reds, and greens, alluding to the main issues addressed in this work: the dangers of nuclear testing and infatuation with technology, and the resulting effects on the earth. Nagatani comments on creating *Alamagordo Blues* in the following passage:

Andrée Tracey and I were invited to use the Polaroid twenty-by-twenty-four-inch camera and have an exhibition in Frankfurt, Germany, at FotoForum Gallery. A primary goal was to direct the new work from some of the humorous images that we had accomplished in the past towards images that had a more direct "black humor" ingested with irony. Throughout our collaboration we worked with and were informed by issues that Spencer R. Weart focused on in his book *Nuclear Fear, A History of Images*.

The source for this work was the well-known image of goggled observers, seated in Adirondack chairs witnessing an atomic detonation in 1951. The picture, titled *Observers, Operation Greenhouse,* was from the files of the U.S. Department of Defense.

I had read somewhere that most of the military personnel in the image had acquired cancer or some fatal disease as a result of the radiation exposure. It was during this time that military personnel were either intentionally or unwittingly exposed to large amounts of radiation as a result of government stupidity and/or experimentation. The image is full of irony as its implications are understood forty-four years later. Our intent with *Alamogordo Blues* was to layer an image with further information in an effort to direct further ironic juxtaposition.

We constructed an adirondack chair and we took large format pictures of Japanese-American friends (both my brothers are models) with ties strung up on monofilament and with hair greased back (to give the appearance of the nuclear wind blast). We printed the black and white negatives on large gelatin-silver mural paper and mounted the resultant figures on foam core board. The figures were hand colored and accurately cut out. The prints spewing out of the Polaroid SX-70 cameras were hand made in various sizes to perceptively force a greater illusion of distance. I posed in the image after Andrée had applied blue theatrical make-up with white shirt, goggles, tie, and SX-70 camera. Our desire to use a "real" figure in the representation installation was to heighten the sense of scale of the installation. The canvas background of an area in Alamogordo, New Mexico, (the historical and contemporary nuclear landscape of American nuclear weapons development) was painted by Andrée in oils. As in our previous collaborative work, the sense of illusion was the main reason to combine the painted "metaphorical mark" with the sharp, informationally loaded photographs. All of the props in the installation were hung with monofilament suspended from a scaffolding that we designed and transported to Germany for the "shoot."

If we were writing about any one of many other Nagatani/Tracey images, there would certainly be a great deal more text on the construction intricacies of the set and the work intensive set-up. *Alamogordo Blues* was a relatively "easy" installation to arrange for the camera. We think that its success rests with the seamless flow from concept to final photographic object. To this day, we feel that *Alamogordo Blues* is one of our strongest images from the collaboration.

Alamagordo Blues, 1989
Dye transfer print
18¼ x 28¼ inches
Purchase, gift of the Photography Alliance of The Chrysler Museum, 91.14

Maria Martinez-Cañas
American (b. Cuba), 1960–

Although born in Cuba, Martinez-Cañas left the island when she was only three months old. Through her photography, she searches for her Cuban heritage by using the fragments of family pictures and stories as inspiration for ideas. Photographing since the age of ten, Martinez-Cañas contact-prints her negatives after cutting and shaping them to create designs based on Caribbean vegetation, old documents, and maps of Cuba. Her work conveys a multi-layered language of personal symbols and references through formal, often abstract presentations. This statement about *Tormenta de Imágenes* is from a 1992 interview:

I feel very strongly about this piece. I think to me this is one of the most unique images that I have made. This piece is a combination of a lot of forms and shapes that have interested me for many years. The title *Tormenta de Imágenes* relates to a storm of images because we're confronted with all these images. This is really the photographer talking much more than the Cuban talking.

I wanted the piece to be totally packed with images that would in a way be very difficult for you to really pinpoint what it is you're looking for. Also if you look at it carefully you realize the line from the bullfight, a line that is out of focus, a line from buildings, and we start again with the bullfight.

There is a kind of movement or rhythm visually that happens on the piece. If you look really carefully you may not necessarily see that. Also a kind of almost claw shape inside the oval shape is the one that has the more organic element and then the female body in the center....

To me this piece was a very feminine piece. I felt that the male had to be there and I felt that it was not for any specific reason you would think. I felt very much that this was a very female-oriented piece. For that reason it had to have the female body at some point on the piece.

The idea of power. The idea of animal and male power more than anything. I've always been fascinated with bullfights. Not necessarily that I do not dislike them. To tell you the truth, I like them very much. I think they're wonderful. I don't want to call it a sport because to them it's much more than a sport. It's an art form. This idea of the duality of male power and animal power. I think that each one of us do also have the type of duality of male and female in us. And it depends on which one we develop more than the other....

The idea of the repetition of the negative and inverted negatives and flipped negatives that I use is because I wanted to recreate a different sense of space. Recreate a reality that in reality doesn't exist because there is no way this can exist the way I put it in. I wanted it to be with that sense of dislocation or location that in reality does not exist. The way I work, specifically with a piece like this, is that the shape inside the oval may not necessarily make any sense and you'll wonder why is this here? What connection does this have with this? It may not necessarily have any kind of connection but I think that our lives in general are very much that way. We're built out of this fragmentation that in some cases has no connection with anything else. I frequently deal with these types of issues.

Tormenta de Imágenes (Storm of Images), 1990
Gelatin-silver print
41 x 41 inches
Purchase, gift of the Photography Alliance of The Chrysler Museum, 92.18

BIBLIOGRAPHY

Bell, William. "Photography in the Grand Gulch of the Colorado River." *The Philadelphia Photographer* 10 (1873): 10.

Borcoman, James. "The Midi de la Photographed." *Charles Nègre 1820–1880*. Ottawa: The National Gallery of Canada, 1976.

Bourke-White, Margaret. *Portrait of Myself: Margaret Bourke-White*. New York: Simon and Schuster Inc., 1963.

Braun, Adolphe. Letter to Paul de St. Victor. Undated. Translated by Marie-Jose Bodi. From the collection of Naomi Rosenblum.

——. Letter to Paul de St. Victor. October 12, 1871. Translated by Marie-Jose Bodi. From the collection of Naomi Rosenblum.

Brigman, Anne W. "What 291 Means to Me." *Camera Work*, no. 47, July 1914.

Bruguière, Francis J. "Creative Photography." *Modern Photography Annual* (1935–36): 9–14. Reprint. *Photographers on Photography*. Edited by Nathan Lyons. Englewood Cliffs Prentice-Hall, Inc., 1966.

Burrows, Larry. See Irvin, *Beautiful, Beautiful*.

Cameron, Julia Margaret. "The Annals of My Glass House." 1874. (First published in *Photo Beacon* 2 (1890): 157–60.) Reprint. *Photography: Essays & Images: Illustrated Readings in the History of Photography*. Edited by Beaumont Newhall. New York: The Museum of Modern Art, 1980.

Carjat, Étienne. "Le Lamento du Photographe." *Artiste et Citoyen*. Translated by Marie-Jose Bodi. Paris: Tresse Éditeur, 1883.

Claudet, Antoine François. "On Photography in its Relations to the Fine Arts." *Humphrey's Journal of Photography and the Allied Arts and Sciences* 12, no. 7 (August 1860): 108–110.

Close, Chuck. Interview with author. May 23, 1995.

Content, Marjorie. Journal entry. November 18, 1936. Marjorie Content Estate.

Curtis, Edward S. Untitled, unattributed, and undated typescript from the Edmond S. Meany Papers at the University of Washington Libraries' Manuscripts and University Archives. Cited in *History of Photography* 2, no. 4 (October 1978): 349–353.

Cuvelier, Adalbert. Letter to Charles Chevalier. Translated by Marie-Jose Bodi. February 12, 1854. Guide du Photographie. Paris: Charles Chevalier, 1854.

Dewan, Janet. Linnaeus Tripe, correspondence to author. April 12, 1995.

Dewan, Janet and Maia-Mari Sutnik. *Linnaeus Tripe: Photographer of British India 1854–1870*. Ontario: Art Gallery of Ontario, 1986.

Duchenne, Guillaume-Benjamin. *The Mechanism of Human Facial Expression*, 1862. Edited and translated by R. Andrew Cuthbertson. London: Cambridge University Press; Paris: Editions de la Maison des Sciences de l'Homme, 1990.

Frith, Francis. "Egypt and Palestine." *British Journal of Photography* (February 1860): 32–33.

Gardner, Alexander. *Gardner's Photographic Sketch Book of the War*. Vol. 1. Washington, D.C.: Philp & Solomons, 1866.

Goodrich, Lloyd. *Thomas Eakins: His Life and Work*. New York: The Whitney Museum of American Art, 1933.

Halsman, Philippe. *Halsman Sight and Insight*. Garden City: Doubleday & Company, Inc., 1972.

Haskins, Jim. *James Van DerZee: The Picture-Takin' Man*. Trenton: Africa World Press, Inc., 1991.

Horton, Anne. *Robert Mapplethorpe*. Exhibition catalogue. Berlin: Raab Galerie, 1986.

Irvin, John. *Beautiful, Beautiful*. London: BBC-TV, 1969. Film.

Johnson, Brooks. *A Progress Report on Civilization*. Exhibition catalogue. Norfolk: The Chrysler Museum, 1992.

——. *Jun Shiraoka*. Exhibition catalogue. Norfolk: The Chrysler Museum, 1988.

——. *Mountaineers to Main Streets: The Old Dominion as seen through the Farm Security Administration Photographs*. Exhibition catalogue. Norfolk: The Chrysler Museum, 1985.

Käsebier, Gertrude. "Studies in Photography." *The Photographic Times* 30, no. 6 (June 1898): 262–272. Reprint. *A Photographic Vision: Pictorial Photography*, 1889–1923, Salt Lake City: Peregrine Smith, Inc., 1980.

Kelley, Mike. "In Youth is Pleasure." Interview with Larry Clark. *Flash Art* 25, no. 164 (May/June 1992): 82–84.

Lange, Dorothea with Daniel Dixon. "Photographing the Familiar." *Aperture* 1, no. 2 (1952): 4–15.

Langenheim, William and Frederick. "The Daguerreotype." *Pennyslvania Arts and Sciences* 4, no. 1 (1939): 21–22.

Le Gray, Gustave. *A Practical Treatise on Photography, Upon Paper and Glass*. Translated by Thomas Cousins. London: T. & R. Willats, 1850.

Mac Orlan, Pierre. *Photographes Nouveaux: Germaine Krull*. Translated by Jill Quasha. Librairie Gallimard, 1931.

Magritte, René. "La Voix du Mystère," *Rhétorique* 4 (January 1962): 1. Reprint. *Magritte: Ideas and Images*. Translated by Richard Miller. New York: Harry N. Abrams, Inc., 1977.)

——. Notes written at the Gladstone Hotel, New York, New York, December 16, 1965. Reprint. *Magritte: Ideas and Images*. Translated by Richard Miller. New York: Harry N. Abrams, Inc., 1977.)

Martinez-Cañas, Maria. Interview with author. April 17, 1992.

Meatyard, Ralph Eugene. *Photographs*. Exhibition catalogue. Carl Siembab Gallery, Boston, Massachusetts, November 1962.

Metzner, Sheila. *Graphis Photo: The International Annual of Photography*. Zurich: Graphis Press Corp., 1994.

Misonne, Léonard. *Léonard Misonne*, Vienna: Edition die Gallerie, [1934?].

Model, Lisette. "Pictures as Art." *The New York Times*, December 9, 1951, 21.

Morgan, Barbara. "Dance Photography." *U.S. Camera* 8 (February-March 1940): 52–64.

Outerbridge, Paul. *Photographing in Color*. New York: Random House, Inc., 1940.

Porter, Eliot. *Intimate Landscapes, Photographs by Eliot Porter*. The Metropolitan Museum of Art. New York: E. P. Dutton, 1979.

Robinson, Henry Peach. *The Elements of a Pictorial Photograph*, Bradford: Percy Lund & Co., Ltd.; The Country Press and London: Memorial Hall, Ludgate Circus, E.C., 1896; New York: Arno Press, Inc., 1973.

Roche, Thomas C. "Landscape and Architectural Photography," *The Philadelphia Photographer* 10 (September 1873): 340-348.

Rodchenko, Alexander. *Rodchenko: The Complete Work*. Edited by Vieri Quilici. London: Thames and Hudson Ltd., 1986; Milan: Idea Books Edizioni, 1986.

Rodger, Thomas. "The Collodion Process." *The Photographic and Fine Art Journal* (July 1857): 212.

Rothstein, Arthur. See Johnson, *Mountaineers to Main Streets*.

Samson, John [Timothy O'Sullivan]. "Photographs from the High Rockies." *Harper's New Monthly Magazine*, (September 1869), 465.

Schwartz, Robin. *Dog Watching*. New York: Takarajima Books, 1995.

——. *Like Us: Primate Portraits*. New York: W. W. Norton & Company, 1993.

Shiraoka, Jun. See Johnson, *Jun Shiraoka*.

Steichen, Edward. *A Life in Photography: Edward Steichen*. New York: Bonanza Books, 1984.

Sutcliffe, Frank Meadow. "How to Look at Photographs." *The Photographic Times* 22 (September 1892): 477–479.

Sutnik, Maia-Mari. *Gutmann*. Ontario: Toronto Art Gallery, 1985.

Teynard, Felix. *Égypte Et Nubie: Sites et monuments*. Translated by Catharine H. Roehrig, 1858. Reprint. *Félix Teynard: Calotypes of Egypt*. New York: Hans P. Kraus, Jr., Inc.; London: Robert Hershkowitz Ltd.; Carmel: Weston Gallery Inc., 1992.

Thomas, Lew. *The Restless Decade, John Gutmann's Photographs of the Thirties*. New York: Harry N. Abrams, Inc., 1984.

Tilden, Freeman. *Following the Frontier with F. Jay Haynes: Pioneer Photographer of the Old West*. New York: Alfred A. Knopf, 1964.

Townsend, George Alfred. "[Mathew] Brady, The Grand Old Man of American Photography." *The World*, April 12, 1891, p. 26. Reprint. *Photography: Essays & Images*. Edited by Beaumont Newhall. New York: The Museum of Modern Art, 1980.

Uzzle, Burk. See Johnson, *A Progress Report on Civilization*.

Vroman, Adam Clark. "Photo Era." *The American Journal of Photography* 6 (February 1901): 269–270.

Warren, Dale. "Doris Ulmann: Photographer-in-Waiting." *The Bookman* (October 1930): 72, 129–144.

Watkins, Margaret. "Advertising and Photography." *Pictorial Photography in America* 4. New York: The Pictorial Photographers of America, 1926.

White, Clarence H. "The Progress of Pictorial Photography." Interview with Henry Hoyt Moore. *Annual Report of the Pictorial Photographers of America*. New York: The Pictorial Photographers of America, 1918.

Wolcott, Marion Post. "Keynote Address" paper read at Women in Photography conference, October 10-12, 1986 at Syracuse, New York.

INDEX